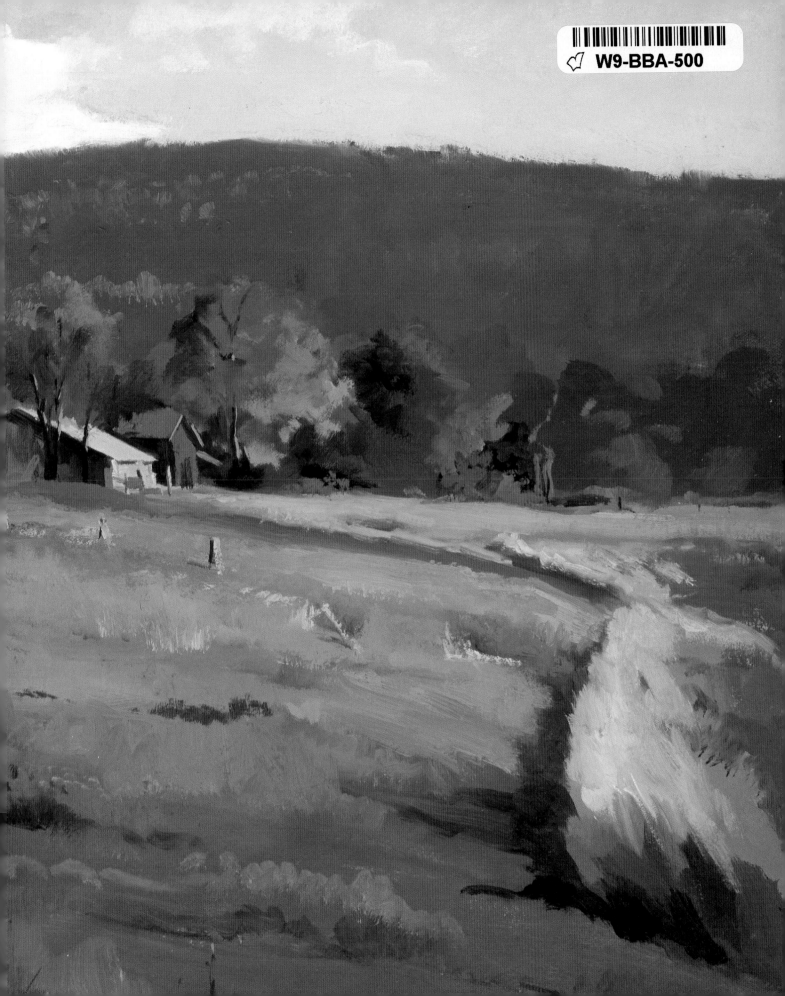

This book belongs to

Judith Meyer

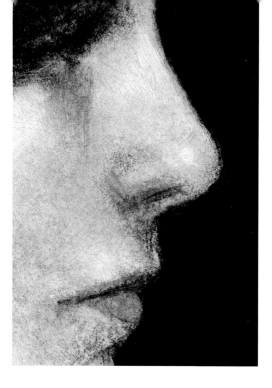

How I Paint

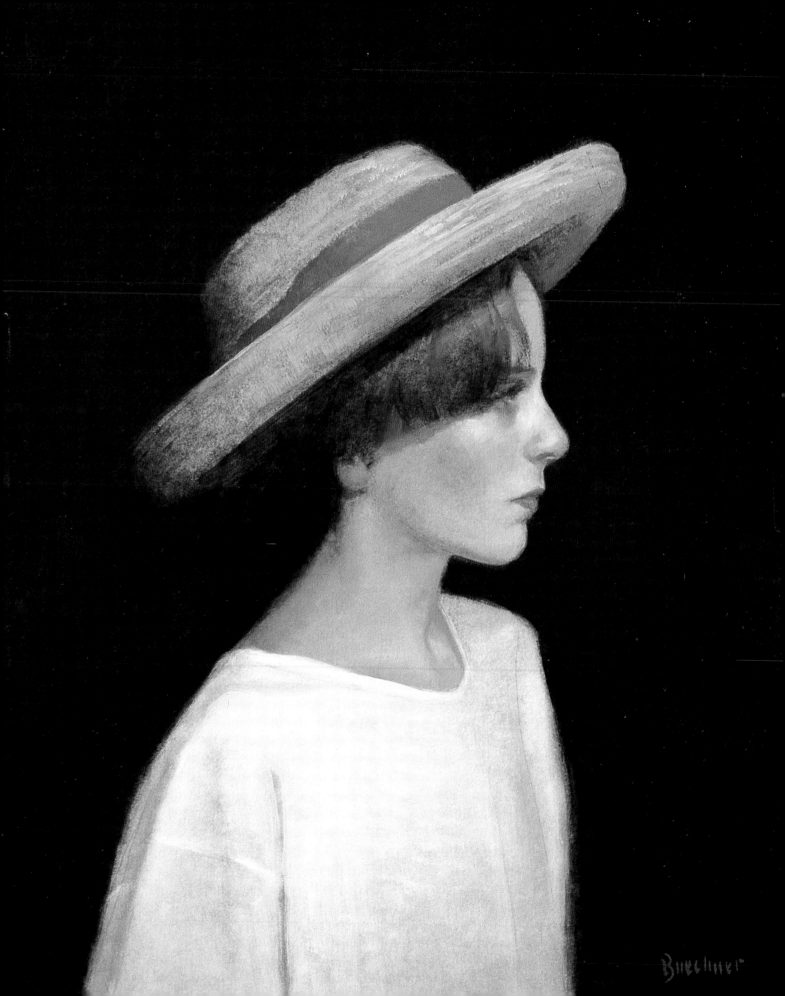

How I Paint *Secrets of a Sunday Painter*

THOMAS S. BUECHNER

HARRY N. ABRAMS, INC., PUBLISHERS

In memory of

Mauritz M. van Dantzig

(1903–1960)

Editor: Barbara Burn
Designer: Darilyn Lowe Carnes

Library of Congress Cataloging-in-Publication Data

Buechner, Thomas S.
 How I paint / Thomas S. Buechner.
 p. cm.
 Includes bibliographical references and index.
 ISBN 0–8109–4153–8 (hardcover)
 1. Buechner, Thomas S.—Contributions in painting technique.
 2. Painting—Technique. I. Title.
 ND237.B8827A4 2000
 751.4—dc21 99–38327

Printed and bound in Hong Kong

Harry N. Abrams, Inc.
100 Fifth Avenue
New York, N.Y. 10011
www.abramsbooks.com

CONTENTS

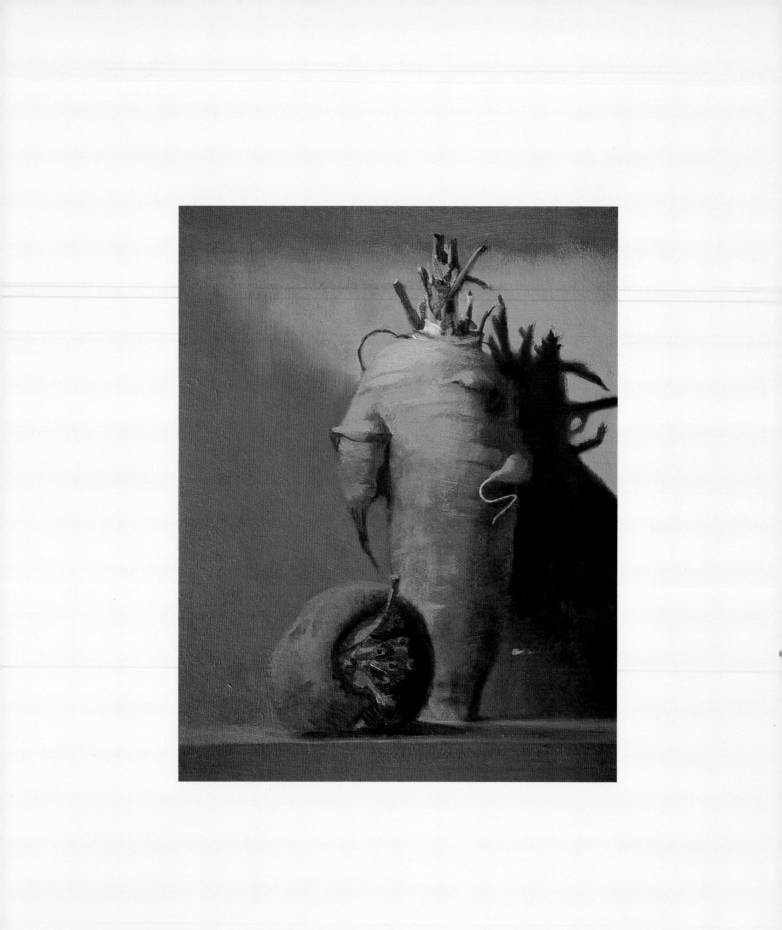

ACKNOWLEDGMENTS

Almost everything in this book came from somebody else; a few things are from my own experience but I am not sure which ones. My parents encouraged me, and my wife, Mary, has always been my best critic. Teachers and colleagues in schools, museums, and design-related businesses and family, friends, and people who just pass by have given me facts, concepts, and opinions, many of which I have adopted as my own. And the artists living and dead to whom I am indebted are beyond counting. My life has been one long, glorious museum field trip, and my house is crowded with art books, magazines, auction catalogues, reproductions, and postcards, each full of visual ideas. Whom and which do I acknowledge here?

I have chosen four. First, Rembrandt for providing the most inspiration. Second, M. M. van Dantzig, a Dutch expert in traditional painting techniques, for showing me how the old masters did it. Third, David Levine, artist and caricaturist, for showing me what gives painting content. Fourth, Aaron Shikler, artist and portrait painter, for showing me how beautiful things are. May all the others forgive me.

Of those who have kept me going over the years by actually paying good money for my pictures, I am most indebted to Howard Kimball: he has eighty-nine. It was through him that the Metropolitan Museum of Art and the National Museum of American Art acquired my work.

The fact that Paul Gottlieb, publisher of Harry N. Abrams, thought this book worth doing was motivation enough; Bill Zinsser, author of *On Writing Well,* gave me good advice, and with Barbara Burn as editor I have had nothing to fear. It has been a trip, and I am grateful to them all.

Thomas S. Buechner
Corning, New York

INTRODUCTION

Last year, my son Matthew asked me what I would like to do with whatever time I have left (I am seventy-three). Painting a really good picture remains my moving target, but tidying up my thoughts on painting also seems a sensible thing to do. As a museum person, I have worked and talked with large numbers of people who don't paint, and, as a painter, student, and teacher, I know many people who do. This book is for both groups.

My purpose here is to describe how my paintings are made so that painting in general can be better understood and enjoyed. Although the text and pictures in this book are mine, the ideas they represent are from all over the place and should be applicable to pictures in general. My emphasis is on technique, because there seems to be so little of it around and because, when understood, it gives original artwork new presence. Have you ever noticed how little is said on museum labels or on conducted tours that requires the original work itself? Almost everything could be just as well illustrated by a photograph or a reproduction. One purpose of this book is to make looking at pictures, at the surface of the original work, a source of insight and pleasure.

This is also a how-to book for people who like to paint. I started teaching in the 1950s and have taught ever since. For the last twenty-five years I have given a weekly painting class here in Corning and, for the last twelve years, courses in Frauenau, Germany, during the summer. This book is an attempt to summarize what I have learned from teaching. The title, *How I Paint*, came from Toni Callahan, a brilliant linguist who translated my lesson plans into German and saw in them a potential book. I like the title because it says this book is about what *I* do and not what *you* should do.

The other basis for the book is a talk I have been giving since the early 1980s called "Sources of Aesthetic Conviction," which is about nine events in my life and the impact each has had on my work. For example, being in the Navy in World War II showed me how

important uniformity is in attracting attention to small differences. The nine events all turn up in the pages that follow, but the point of that talk and this book is to encourage you to look for your own convictions and their sources.

When I started thinking about this project, I saw it as a way to show my best work. I have painted about twenty-five hundred pictures and was faced with choosing roughly fifty. Being museum trained, I have photographs of them all. In the first cut I took ten percent—250—and laid out 4 x 6" prints all over the living room. My wife had opinions, and so did everyone who came through the house, and we got the total down to one hundred. As I started to write, the images became partners with words in trying to make things clear, clear to me, and my choices changed radically. I stopped all work on commissions and started to paint and photograph stages in the process of painting, in order to illustrate what I think is true. The book became like a painting. It had its own requirements, and these determined the final choice of illustrations.

Preparing this book has been a tidying-up process. The photographs are gone from the living room, and I have checked off all the subjects I wanted to cover, and now I can get back to painting, the focus of my life.

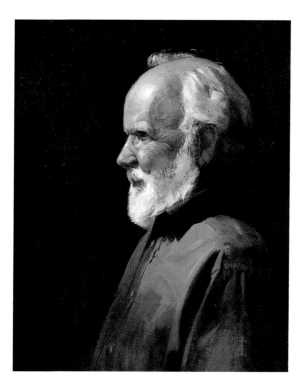

WHY I PAINT

I first visited the Metropolitan Museum of Art with my grandfather in the early 1930s. He was keen on snuffboxes and lifted me up so that I could see them closely and appreciate the difference between boxes made in Dresden and those made in Prague. I wanted to see *Washington Crossing the Delaware* by Emanuel Gottlieb Leutze, but Grandpa didn't think it worthwhile—too big. When I was ten, I was allowed to go to the museum by myself. There were few visitors in those days, and I could wander through gallery after gallery without seeing anybody except the guards, some of whom I knew by name.

I got to know that building pretty well. Besides snuffboxes, paintings, and knights in armor, there were rooms full of furniture, huge stone lions with human heads and humans with animal heads, as well as humans with no clothes on; there were books with polished gold letters, old-fashioned clothes made of lace; dishes and bowls and pots of every sort in silver and gold, glass, and clay. I remember a cow's horn with bands of metal around it that you could drink from. Everything was decorated, even the coffins; one was made out of a single block of marble and had a whole war carved into it. And there were swords and daggers, rifles and pistols, most of them too beautiful to use.

The museum seemed to me a palace where all kinds of things were gathered together and sorted out. Everything I saw in this enormous building, thousands upon thousands of objects, appeared to be made, not by machines, but by hand. My everyday world was about cars and planes, movies and radio programs, skyscrapers, comic books, the 20th Century Limited. My museum world was about things made by hand, by individual people. Their names were on the labels to prove it, unless the objects were made so long ago that nobody remembered. Out of all this came the idea that I might, someday, make things all by myself that would be good; the museum was about possibilities, about what I might be.

The other idea that came out of these years had to do with defining art. The museum is called the Metropolitan Museum of *Art,* and it contains just about every kind of thing that

people once made. I assumed then, and still assume, that things were chosen because they were good—very good, maybe the best—examples of their kind. So I see art as a matter of relative quality rather than as confined to a particular discipline such as painting or sculpture. I am still uncomfortable with the person who says "I've decided to be an artist" or "I make art." To me that's like saying "I've decided to be a master"or "I make masterpieces." We can only decide to try. (On the other hand, I have no trouble calling my plumber an artist when he solves all my problems efficiently and at reasonable cost.)

The point of all this is that those early years spent exploring the Met set me apart from most of my contemporaries in art school. The other kids were about originality, abstraction, and self-expression. I was about copying, technique, and trying to do better than I had done the day before. The Met was my bureau of standards; to most of my fellow students it was a past to be left behind.

The pleasures of painting came early. I could do it by myself and my parents approved. At twelve, I was the only kid in a Saturday-morning life class, and I sold a pastel of a Benedictine bottle when I was thirteen. At home after school, I copied Rembrandt etchings from a book and, a few years later, got permission from the Met to copy Titian's *Venus and the Lute Player*. I have never painted as well as I thought I should, so frustration came early, too. *My* Venus looked like a bag of laundry.

In 1994, for the fiftieth reunion of my class at the Lawrenceville School, I made a list of the different things that painting means to me. Here is an updated version:

being alone with myself	facing infinite possibilities
being part of an enormous family of painters, living and dead	mastering a medium or failing to do so
	showing and telling
being amazed by reality	bringing pleasure, making money
seeing how strong or weak I can be	thinking
seeing the evidence of passing time	transcending myself (very rarely)
just seeing	

And I get to travel, paint with friends, visit museums, and buy art books as legitimate business expenses.

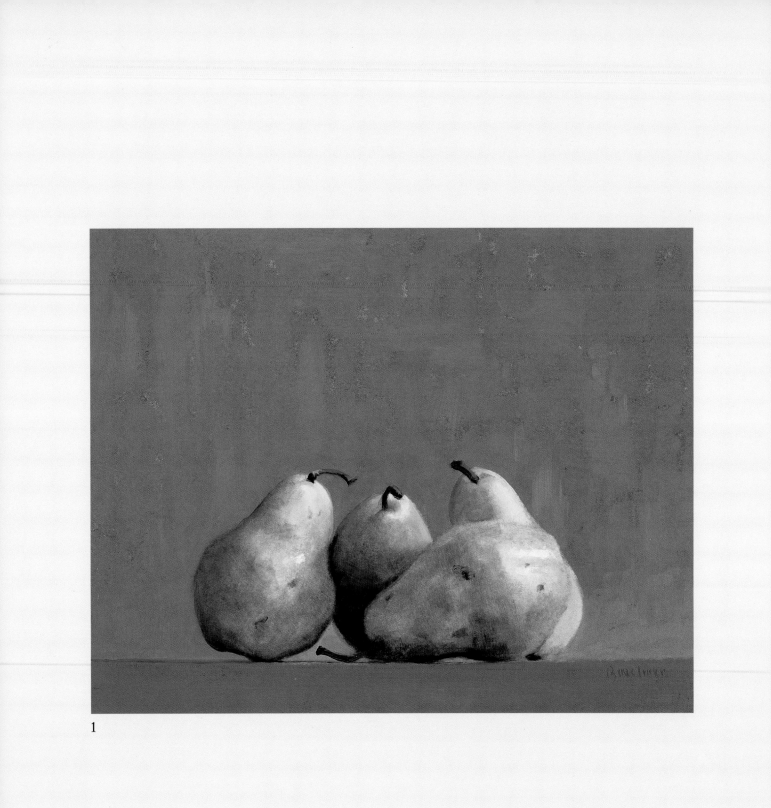

1

WHAT TO PAINT

This chapter is about getting started, choosing a subject. I first narrow the field by asking myself two questions: *Why* am I going to paint this picture? and *What* will it be about? Answers to the first can range from "because I've nothing better to do" to "because I'm burning with passion and must express myself or die." In between are a whole range of motivations, such as making a present for my wife, meeting a deadline on a commission, getting ready for a show, doing a demonstration for a class, experimenting with materials, or learning someone else's technique. Just being attracted to a subject—a flower, a barn, or a face—may be reason enough. I want to know *why* because it helps me with the *what* question. If the picture is for a show, what I paint will be influenced by what the gallery can sell. If I want to paint a picture because I'm simply drawn to a subject, I have to figure out the reason for my attraction.

For example, I like pears. In spite of their simple geometry, cone on sphere, they seem rather human. Hard or soft, they bruise easily. The four pears in **(1)** are plump and maternal; their stems are like gossipy periscopes, peering here and there; in a clump, they become a family, pushing and shoving, supporting, or sleeping. On pages 65–67 I describe *how* I paint pears; this page is about *why*.

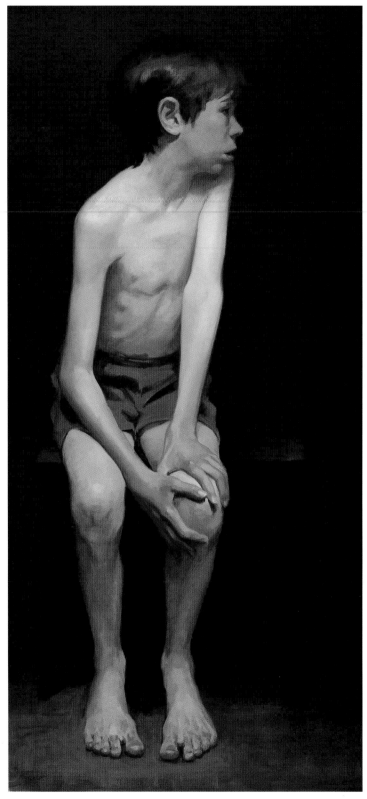

2

When the annual "Artists of America" show in Denver celebrated its tenth year in 1990, I sent in a picture of a ten-year-old boy named Ian **(2).** He is the subject, but the painting is really about uncertainty, about not knowing the future, not even being sure of the present. It is a parallel to the AOA exhibition itself, which struggles between its dual goals of fund-raising and maintaining high aesthetic standards. The subject was chosen for a specific purpose, to serve as a metaphor for this confusion, which influenced the pose, colors, shapes, and textures. In other words, *Ian* was a message. (It was also to be shown with the work of my peers, painters whose good opinion I value.)

I painted another boy of about the same age **(3)** for an auction to benefit the Phillips Collection in Washington, D.C. This picture is much softer and more appealing than *Ian*. It is painted in slow-drying oils and a much brighter palette of colors, with a lot of blending and spontaneous brushwork. The purpose was to attract attention at a society auction.

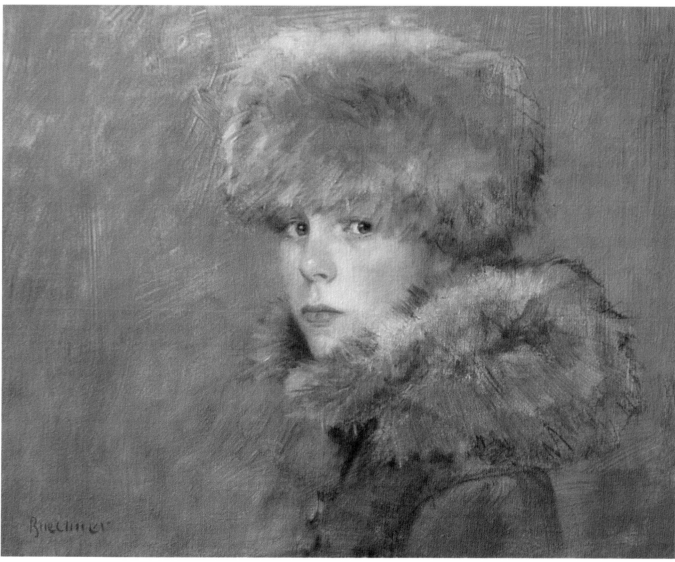

3

Willa **(4)** posed for a class in portrait painting that I was teaching. I always paint when I teach so the other painters can actually see me do what I have been talking about. That is *why* the picture was painted. It was a demonstration. *What* it is about is a particular technique in which a light flesh tone is painted over a darker middle tone, greenish in this case. I started off scrubbing the light tone on very thinly so the darker tone underneath would show through. As I built up the thickness of the flesh tone, it obscured more and more of the greenish layer, giving the same effect that a second coat gives when you paint a wall. Using this technique, I can achieve a range of tones and make the face look three-dimensional. More about this later (page 87). My purpose was to make this method clear to the students, but Willa is such a stunner (nobody wears a hat like Willa!) that I got all involved in the idea of the sultry child. So much for thinking you're in control.

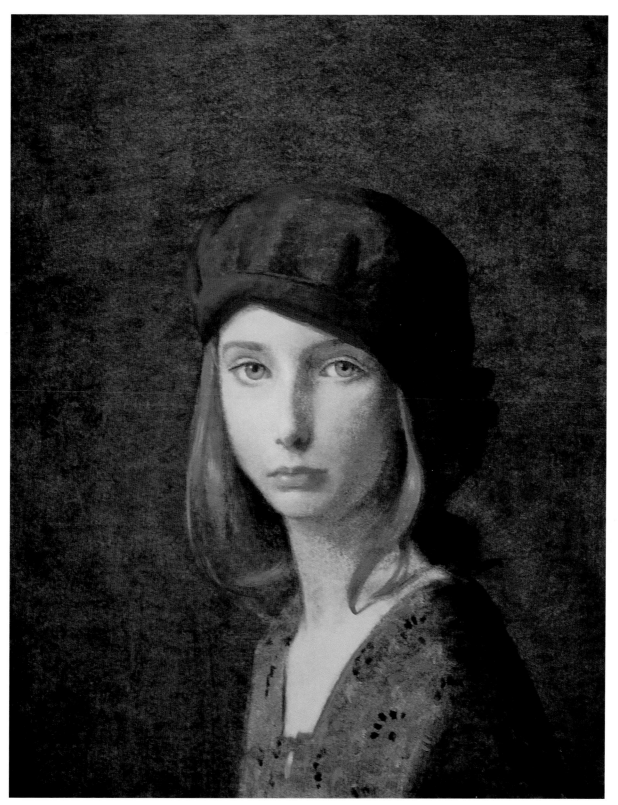

4

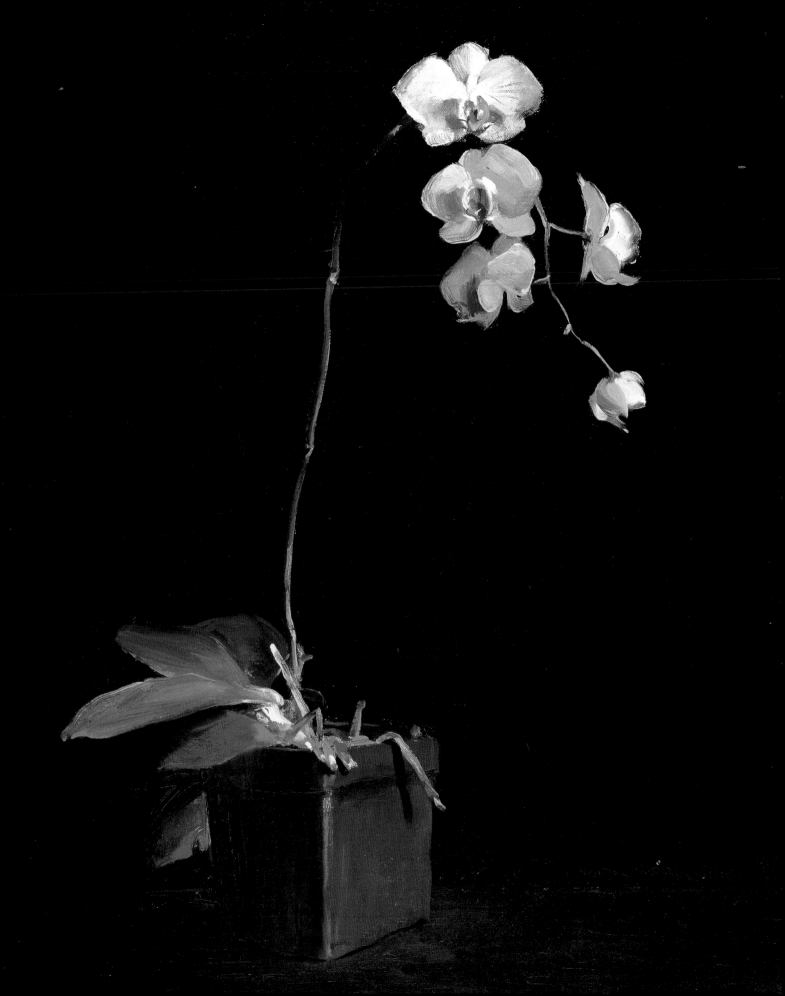

Flowers sell. Purpose enough and I paint a lot of them. My wife also grows them in profusion. They are nature at its loveliest, but they are also extremely fragile, short-lived, and structurally awesome. You can watch them die. The supermarket where we shop on Saturday mornings has a flower display right by the entrance. It is intimidating. Everything else looks pale or dull or vulgar by comparison. All of these plants and blossoms are about spring and the tropics, and we are about winter and slush. But when I pick out cut flowers to buy, the generalities fall away. One bud is bursting with promise, another is tired from the trip to Corning; each disk of petals bellies in or out in its own way, pistils and stamen at the ready. Some are in a great crush to get the most light, while others stand in rigid groups with their lifeline stems all at different angles. They can represent each of the seven deadly sins or the five cardinal virtues. I bought an orchid once that was positively lustful **(5)**.

Reality and Imagination

When I was a Cub Scout, my talent for drawing helped make up for all the things I did badly, like sports. I could do Donald Duck on demand. Curiously, this facility for drawing or painting always amazes people. They gather around to watch anyone at an easel in a public place. They say they can't draw a straight line but that they have an aunt (never an uncle) who can. Talent is equated with getting things right, with having such awesome control that you don't even need a ruler.

The element that amazed my fellow Scouts was the appearance of Donald Duck from the point of a moving pencil with nothing to copy from. It came from inside. The classic put-down on seeing a finished drawing was, "You copied it." On the other hand, the highest compliment was "You made it up." This was even better than producing Donald Duck from memory, providing it looked "real." Looking out at something and drawing it were somehow less impressive than looking in and drawing from recollection or imagination. What you made up was yours, what you saw was common property. This is a powerful choice. Painting from within dominates the art of the twentieth century, just as images derived directly from nature dominate all the centuries that came before. And there's no clear line between painting from fact or fantasy. Imagination and memory are present in both.

5

19

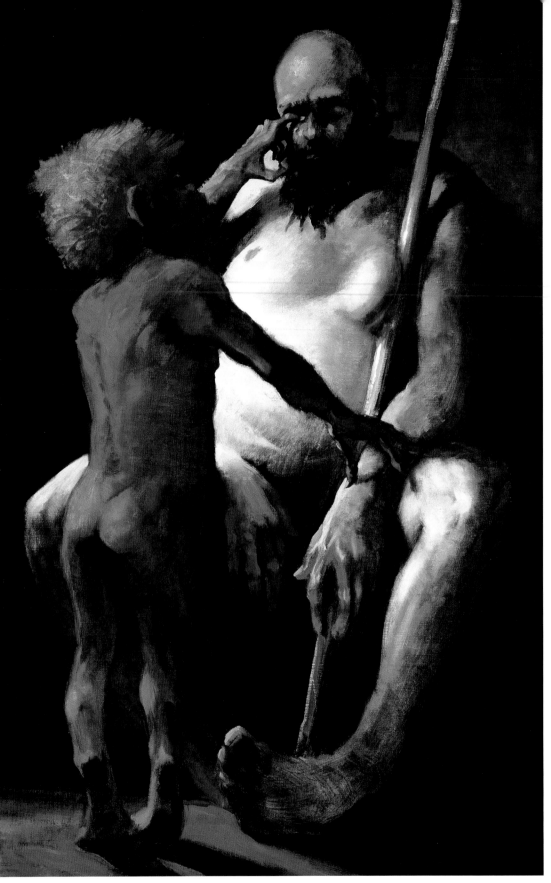

Figure **6** reproduces a picture that I made up—no models, entirely out of my head. The dwarf Albrecht is whispering to his sleeping son, Hagen. These are evil people from the opera *Götterdämmerung* by Richard Wagner. This is not the scene I saw in the opera house, but it's the way I think it should look, given the music and the story. The great advantage of this kind of painting is that you are not distracted by reality, you can get right to the point. The disadvantage is that you can't explore and choose from all the glories of reality.

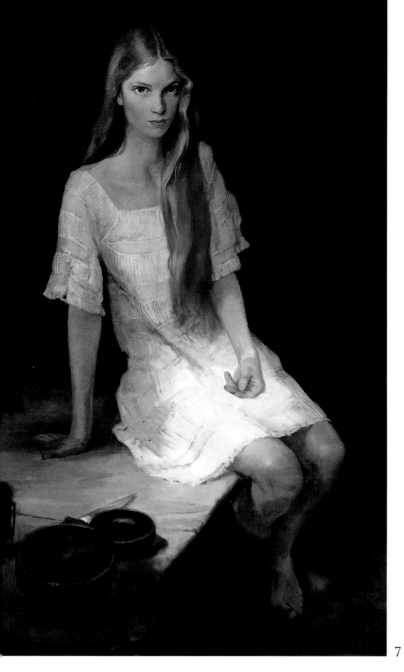

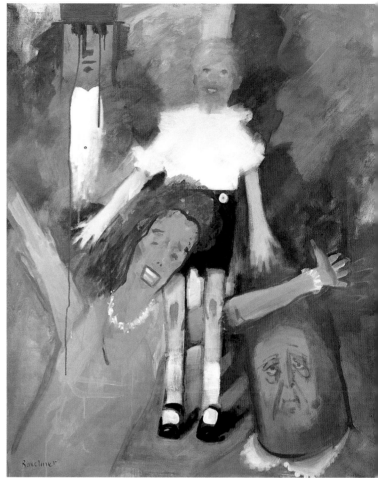

8

7

When I painted Sieglinde **(7)** from another of Wagner's operas, *Die Walküre*, a friend's daughter was the model (she later became a surgeon), and I tried to combine what I saw with what I imagined. My fantasy pictures tend to illustrate other people's stories or to be about me **(8)**. If I had to choose between working out of my head or from something I can see, I would take the latter: first, because I can learn; second, reality is infinitely more interesting than anything I can imagine; third, by painting what can be seen, I become part of a shared experience. Painting is self-centering enough without doing it in the closet of my mind's eye.

Once, when I was a student in New York, I wanted to do a picture of myself painting in the little room where I lived on West Fifty-eighth Street. My concept required that I be in profile, and I asked another student to draw me from the side, so that I could copy her drawing into my picture. She was talented, and I knew she would get it right. That's what talent is. Everyone said it was a good likeness, but to me it had something of her look in it. My profile through her eyes came from inside as well as outside. We can choose to work from imagination or reality, but vision is unique; there's no other human camera like me or you.

Knowing, Seeing, Wanting

Every picture I paint is a three-way struggle between what I know, what I see, and what I want. Little kids draw what they know: the sky is up, so blue appears at the top of the page; Mommy is important, so she's big. As we get older, we try to copy what we see: the sky goes down behind the land; Mommy looks dark when she stands in front of the window. Then comes wanting: how to make the sky threatening, Mommy a refuge. This desire level is wide open. It can be about wanting to create certain abstract shapes and colors, about expressing views on politics, religion, sex, or anything, but without it, talent and skill have no place to go. And the reverse is true: passion is powerless in the hands of the inept.

My painter friend Jim Pryslak (9) has round, brown eyes that are very steady. I know him to be kind and gentle—he's also well proportioned—but when he came into the studio one day in January a few years ago, I saw him differently. His big black overcoat changed him. What I knew of this gentle person was altered by what I saw under these particular conditions. What I wanted was to paint an arresting image, to interest people in his identity, to raise the question: Who is that man? I reduced his size, enlarged his head, merged him into his own shadow against a dull, red wall (lit low), and went after the face as if it were a fallen angel's.

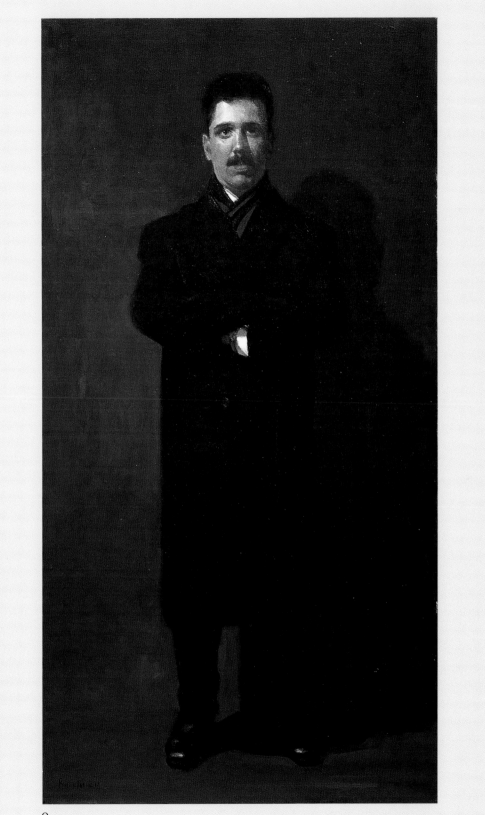

9

Content

Subject plus attitude equals content. Leslie **(10)** came into my life when I was trying to sell my car. She was in her early teens, dressed in jeans, thin, tall, and elegant. Her parents didn't buy the car, but they did let her pose. My wife produced an elaborate nightgown from her costume trove, Leslie was transformed, and I started painting. Although the subject is clearly a girl in white, the picture is about apprehension—hers and mine. This wasn't a conscious decision; it just happened. Leslie was being stared at by an old man in strange surroundings, and I was being overwhelmed by the pictorial possibilities and my limitations. The pose and the look were her response, and the picture was mine. What a painter thinks and feels about a subject is the real content of a painting. An apple recommended by a doctor will be painted differently

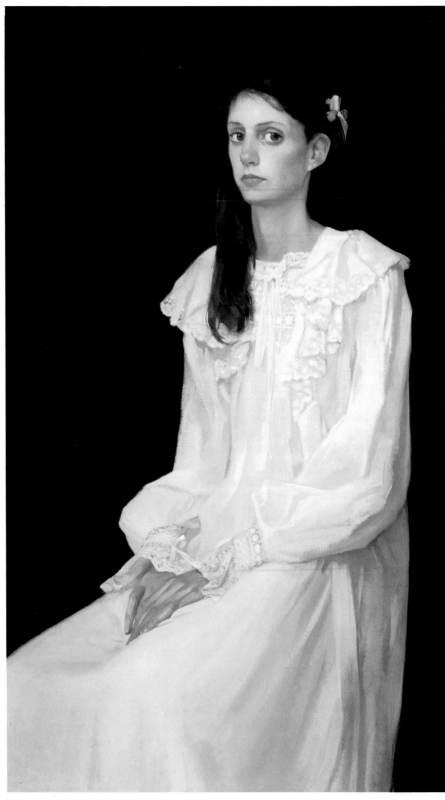

10

than one proffered by a witch. Leslie is isolated by the dark, empty background, which merges into her hair and reaches over her shoulder, pressing down toward her protective hands, like an animal's paw. This is what I see now twenty years later; at the time I was enchanted with her ear, her long fingers, and all the lace. The big decisions were made subconsciously.

Alex (11) is an even younger teenager painted against a black background. Based on the story of David and Goliath, the picture is quite deliberately about coolness. The boy, my grandson, is not thrilled to be posing, and he looks out of the picture with profound apathy. I see myself in the head under his nonexistent arm, cheerful, loquacious, severed. Age done in by youth. So much for conscious intent. The fact is that we are both without bodies; my head is a waning moon. If you can imagine pictures of Alex and Leslie, good-looking kids, without evidence of the painter's attitude, you can imagine pictures without content. Visual echoes at best.

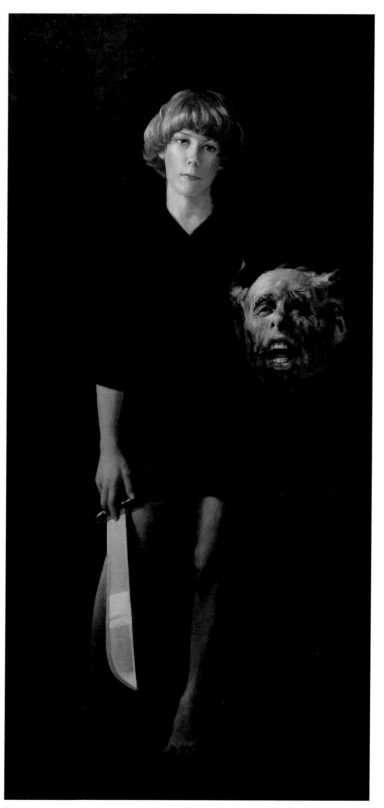

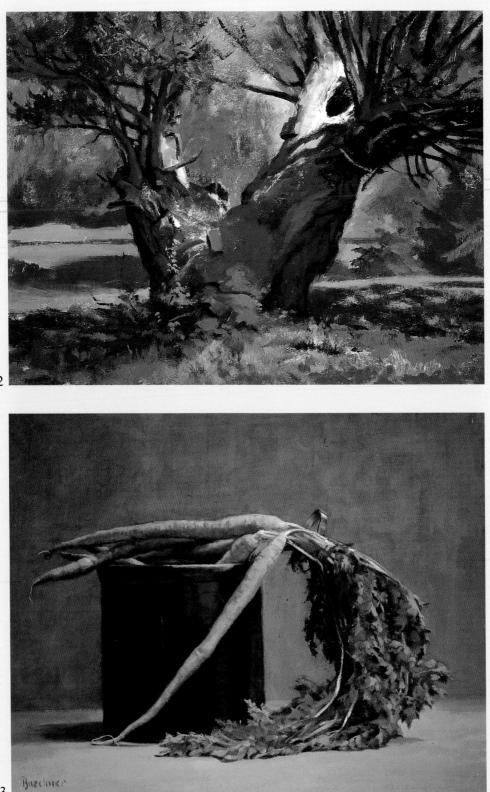

12

13

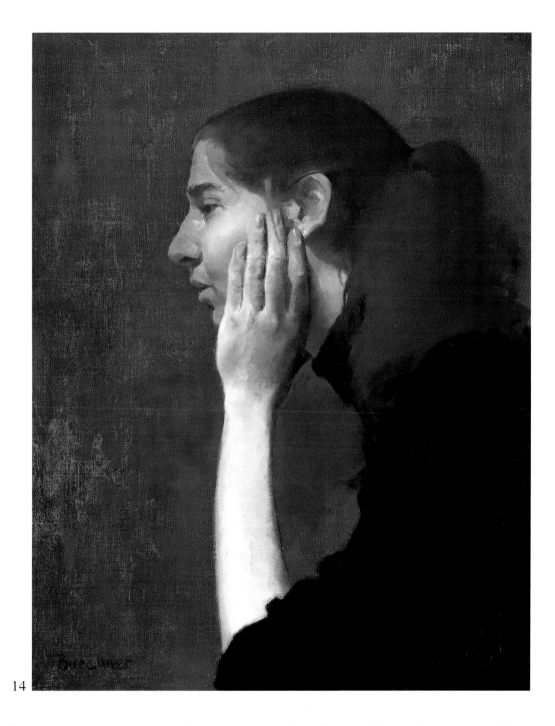

14

Subject can determine approach or approach the subject. I chose the dying tree **(12)** to make a point about the way time moves at different rates for different things. The carrots, *Exhaustion* **(13),** reminded me of trying to get out of bed in the morning and having only one leg succeed. *Melancholia* **(14)** was my reaction to the model in an evening art class.

Still Life, Landscape, or Portrait?

I am really in charge when I paint a still life. The choice of the objects is mine; I can arrange them exactly as I want them, and the light comes from whatever direction I choose. And they stay still. And the light doesn't change. What's more, I'm in my studio alone, comfortable and in control.

Landscape, on the other hand, is full of stress: the light is constantly changing, it is usually too bright, too hot, or too cold. You need protection from bugs, the sun, the wind, and the people. But landscape is big—even a patch of sky leads off forever, and the great clocks of the sun, the seasons, the years are everywhere evident. Still life is intimate and personal; landscape is grand and public. Being city bred, I am easily overwhelmed by the size of the American West or the wildness of the Adirondacks. I like landscapes with buildings in them, preferably in a state of decay. In fact, most of the barns I've painted here in western New York State have subsequently fallen down, no fault of mine. In 1993 David Levine suggested we paint together in Rome. Our first subject was the Castle Sant'Angelo; next, we painted the Colosseum and then took refuge from the gypsies in the Forum, which was fenced in. Here is a man-made landscape built and rebuilt by caesars, popes, and bankers who employed the greatest artists and architects of their time. Now an imperial ruin, the Forum is a graveyard of grandeur **(15)**.

Painting people is what I like to do best. We are all so similar, roughly the same size and with most of the same equipment (which is why we memorize those proportions in art school). In one person we see all people, including ourselves. Even the differences between us—on which individual likeness, personality, and mood rest—can seem familiar. Who is not part anxious child, part confident adult, simultaneously suspicious, unassuming, gentle, brutish, or anything else we might encounter in another? All the variations describe only us.

In deciding what to paint, I don't have to choose between people, places, and things. Most painters can do them all, but each type of picture has its own requirements.

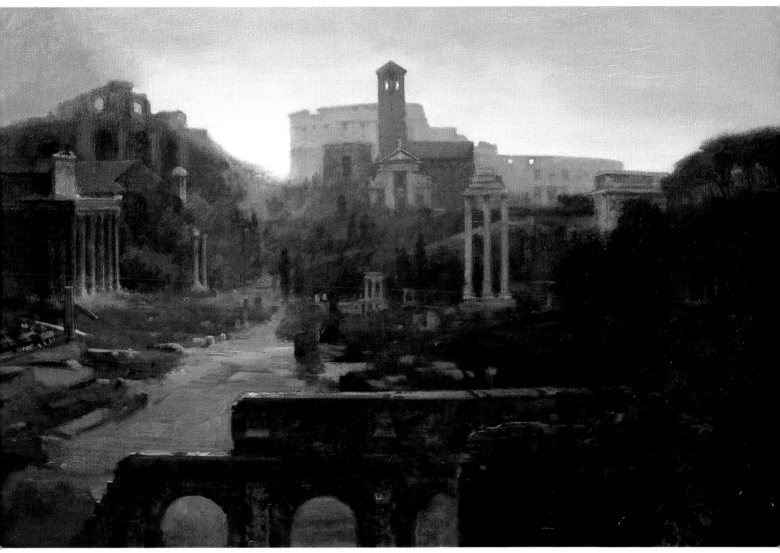

15

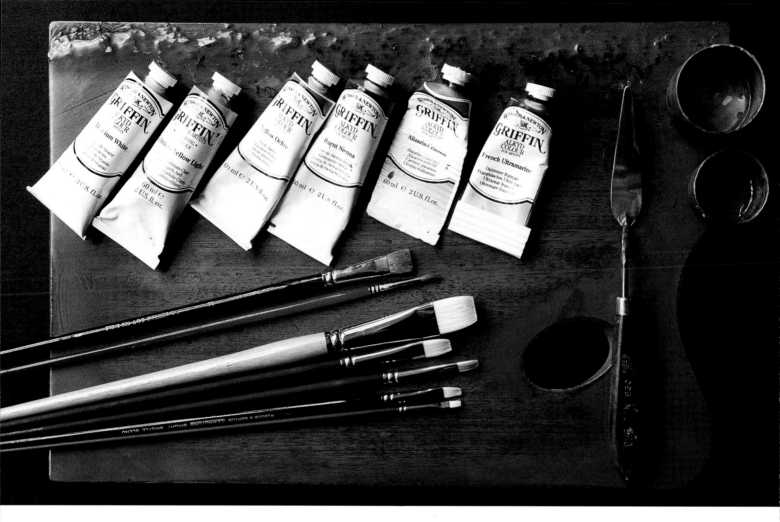

16

HOW I PAINT

Materials and Tools

I used to grind my own paint, make glue from chicken bones, and polish handmade gesso panels with an agate burnisher. I spent much more time on materials than I did on painting, and this is what I got: options. I learned how to make surfaces more or less absorbent, to make paint more or less translucent, thinner or fatter, runny or short, fast drying or slow drying. I learned different systems for laying on paint—Italian, Flemish, Dutch, English, and French—and how the hair of different animals—hogs, sables, badgers—delivers paint. I even learned ways to make paint look old. But most of all, I learned to keep things simple.

All colors come from red, yellow, and blue. Black makes them darker, white lighter. Currently I start with six colors on my palette: yellow ocher, burnt sienna, ultramarine blue, cadmium yellow light, alizarin crimson, and titanium white. I put tubes of these in a French folding-easel box with a range of brights (these are short and square hog's-hair bristle brushes that provide both a crisp edge and a broad stroke) and two sables, one flat and one round (these are soft, good for blending and fine detail). I usually paint on an absorbent surface called Multimedia Art Board, or on a single-primed linen canvas, medium to fine in texture. The board is very absorbent, like a blotter, whereas the acrylic primed canvas can be wiped clean. Mineral spirits both thin the paint and clean my brushes, and the alkyd medium I use is called Liquin. It makes paint transparent without letting it get runny as mineral spirits or turpentine used alone would. It is glossy and keeps colors bright and clear, ideal for glazing. Liquin dries quickly, so I don't have to wait long before continuing to paint. That's it. If I am

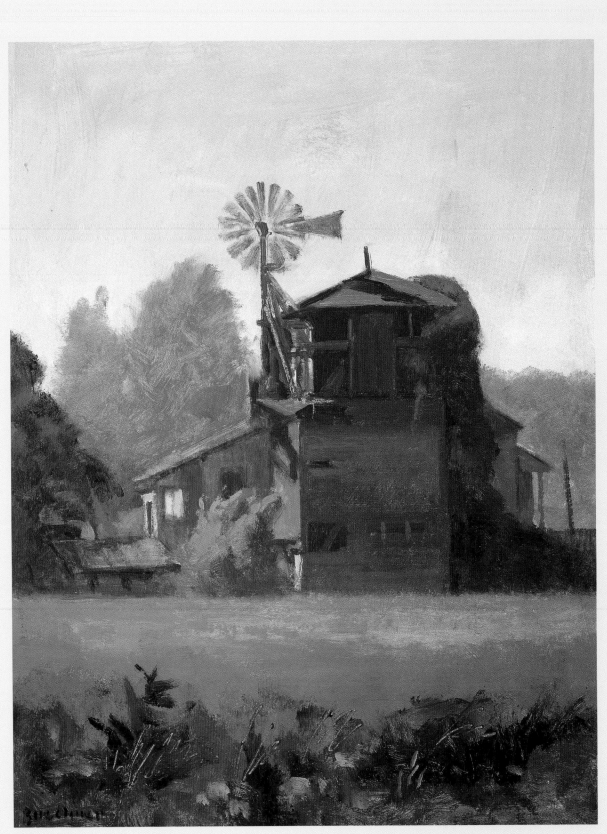

17

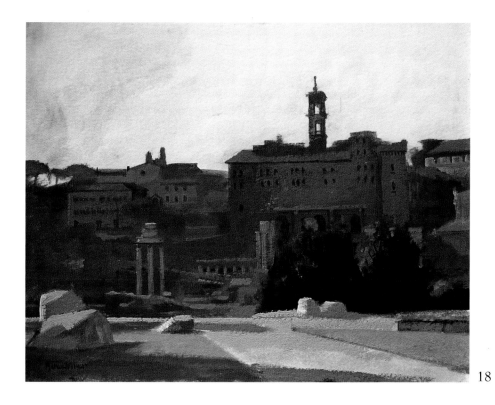

18

packing up to go painting in the wilds of Sonoma County **(17)** or to fend off hordes of tourists in the Eternal City **(18)**, that's what I would take—today. Who knows about tomorrow?

But back in my studio it's a different story. There are hundreds of colors, types of brushes, panels, rolls of canvas, oils and varnishes, some half a century old. I have capucine yellow for painting the pink in children's cheeks, a brush called a striper for doing the wires that connect telephone poles, Maroger Medium for old-master luster. To me an art-supply catalogue is like Aladdin's cave, full of treasure I can hardly wait to get my hands on. Materials and techniques are stimulating, even inspiring. I collect other painters' systems the way a cook collects recipes. In the recently published book *Alla Prima,* the artist Richard Schmid suggests an exercise to become acquainted with the range of his palette of colors. As directed, I dutifully made 720 different combinations and painted each into its own tiny square. It was worth it. I saw how much I have to learn about high key colors (colors mixed with lots of white, as in landscapes by some of the Impressionists). There's no end of things to learn. On the other hand, look at the masterpieces Rembrandt made with nothing but brown ink and a reed cut from the riverbank.

Drawing materials, especially papers, come in huge variety and lead naturally into the complex worlds of pastels and watercolors. Good books abound on both subjects, and as I am far from expert in either, this is not the place to list my favorite colors, brands, and brushes. Besides, most of what I write here is intended to be helpful in the picture-making process regardless of the medium. I have always been urged to draw; everyone told me that drawing is the essential prerequisite to painting and that nothing good could come of a painter who didn't make drawings. But drawing and painting were always presented to me as separate activities. I now see them as inseparable. Does a pencil make a drawing and a brush a painting because of the thickness of the line? Is charcoal on canvas any less of a drawing than charcoal on paper? As this book shows, I draw as a stage in making a painting with a pencil **(21**, **29)**, with charcoal **(74)**, or with a brush **(44)**. And sometimes as a finished work **(33)**, in this case with Conté crayons.

The Camera

My daughter, Bohn, sent us a snapshot of her daughter, Amelia, from which I painted *Tiger Hat* **(19)**. The photograph was taken in Bohn's kitchen, with the sun coming in from behind, making harsh diagonals across the floor. Amelia had gotten herself up in this outfit and had been asked to wait while Bohn got her camera. The painting is a reflective, patient moment touched by the crazy sadness of childhood, but I never saw the moment, and if I had, I could not have drawn it. This fraction of a second in Amelia's life was caught by a camera.

I try never to be without one. It's an idea machine, it can stop the sun, freeze a flower, nail an expression. When someone sits for a portrait, initial self-consciousness generally gives way to boredom. I can take a hundred close-up photographs as we talk and thus gather a range of expression that I could never amass in sketches. The same telephoto lens will magnify the inside of a flower or focus on a distant rock formation. A camera can be used the way most painters use a piece of cardboard with a rectangular hole cut in it—a viewfinder—to locate and frame a subject. Many painters warn against using photographs, because there is no sense of volume, the color is inaccurate, and movement and life are just not there. These painters are invariably better draftsmen than I am. But we do agree on one

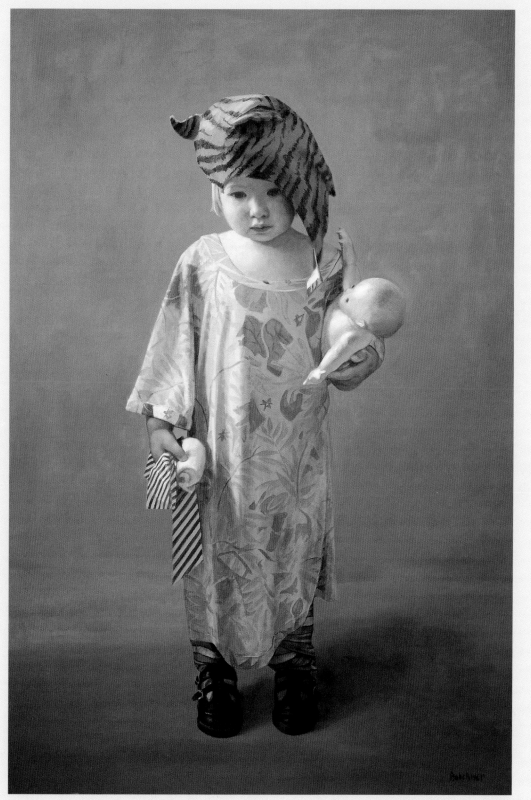

19

thing and that is this: if you copy a photograph, that's all you get. It should be a point of departure, a source of information, or the reminder of a moment. The camera is indiscriminate, but so is a brush; they are both splendid tools.

To be more specific, I use two cameras: in the studio, a big Canon 35mm Single Lens Reflex (SLR) with a variety of lenses; in the field, a small Pentax view camera with a 38–160 built-in zoom. I hate to carry a lot of stuff, but on a portrait shoot I take two SLRs in case

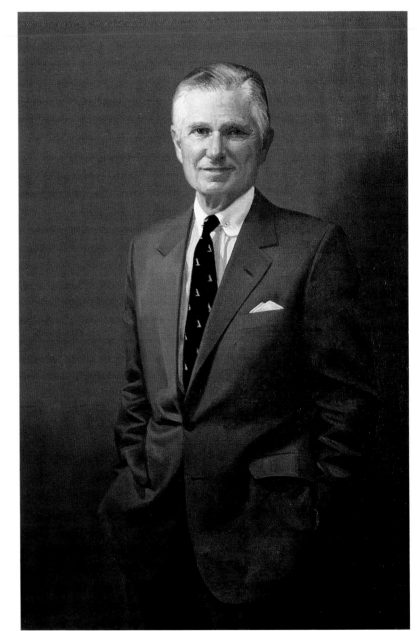

one fails, a tripod that brings the camera to my eye height, and a single halogen lamp, stand, and reflector. My primary SLR has a remote shutter release, so I don't have to be near the camera to take a picture. Prints are easier to handle than slides, but the color is nowhere near as accurate; on the other hand, slide film is far less tolerant of low light levels and the color of artificial light. Print-film processing machines are everywhere and they are flexible: you can have your prints made darker or less yellow or whatever you want. When using artificial lighting, I get two prints from each negative, one for what is in the lights and one for what is in the darks. The man in this portrait **(20)** was painted from photographs I took in his office using a single halogen light bouncing off a twenty-year-old silvered umbrella.

20

Starting

In the beginning is a white rectangle. What size? What dimensions? Ever since I learned that Rembrandt's huge *Night Watch* was arbitrarily cut down from an even bigger picture, I haven't felt too precious about proportions. Virtually every type of support comes in handy 8 x 10, 11 x 14, 16 x 20-inch sizes, which are easily transportable (16 x 20 will fit in the upper half of a garment bag). From there I go to 20 x 24, 24 x 30, 30 x 40, plus two more elongated rectangles, 24 x 36 and 30 x 50, usually for portraits. Of course, there are special situations demanding special sizes, but standardizing has two great advantages. I compose in familiar territory and know at a glance how any subject will fit. And frames are inter-changeable.

I once asked my father where to begin a picture of a person. "The eyebrows," he told me. Today my answer to that question would be: It doesn't matter. I usually try to divide the surface into a few unequal spaces that have some abstract impact. Establishing big shapes, big contrasts at the outset is my preference, but working out from a single point (such as an eyebrow) can be just as successful. Another approach is to start with small thumbnail sketches, a couple of inches square. I have to think big when the scale is small, and I can easily try out different compositions. Thumbnails are especially useful in landscape painting **(21)**.

21

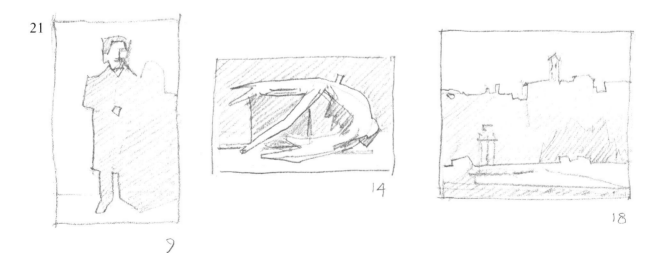

For portraits I may do a careful preliminary drawing in charcoal, both to educate myself and to get the client's approval on my approach, or I might go right off with a full palette of colors, working from the general to the specific, with big, loose shapes gradually refined into final contours and features. In choosing the illustrations for this book, I realize how inconsistent I have been, how strongly influenced by other painters, exhibitions, and books. One day it's the 1820s Roman landscapes of Jean-Baptiste Corot, then I am into the late-nineteenth-century New England countryside with George Inness or back into the riverbank views of the seventeenth century Dutch artist Jan van Goyen. I have taken workshops with wonderful young painters who delight in Edgar Payne and the California Impressionists. It is all stimulating. There is no right way, and each system has its advantages and disadvantages.

Composing

Composing is organizing, which I really enjoy doing. Figure **22** shows a grapefruit with a section cut out and the knife that did it. The picture is pure geometry—straight lines and arcs. The shapes are unequal but also repetitive: the horizontal made by the top of the slice enters the curve of the grapefruit just as the horizontal of the knife handle enters the curve of the other side. There are six arcs and six horizontals. Small tensions are set up where things almost, but not quite, meet: the left point of the slice and the arc of the rind; the blade of the knife just above the base of the grapefruit and just below the rind of the slice. Even the armature of the whole piece, a sort of upside-down T, is not quite on center. I try to compose in both senses of the word, as a creative action and as a way of bringing disparate forces into harmony.

In *Five White Tulips* (**23**) the T is right-side up, and the contrast between the straight lines of the man-made forms and the curves of the natural forms is even greater. With so heavy a mass of absolute verticals and horizontals in the middle, the flowers are intended to float, almost frivolously so. Four of them make up another T at an angle to the top of the vase, while the fifth, on the left, is a counterweight with its petals curving back in flat symmetry. The whole arrangement is supposed to bring final focus to the only tulip that can be entered.

22

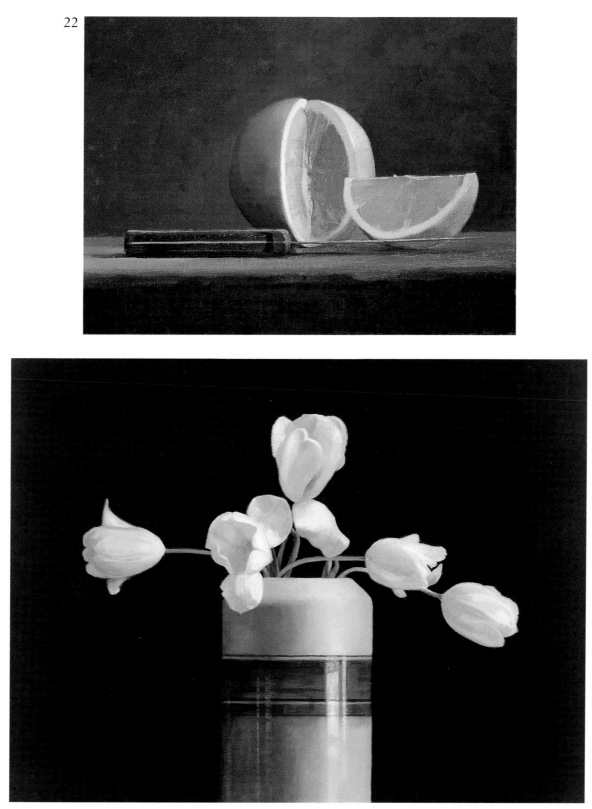

23

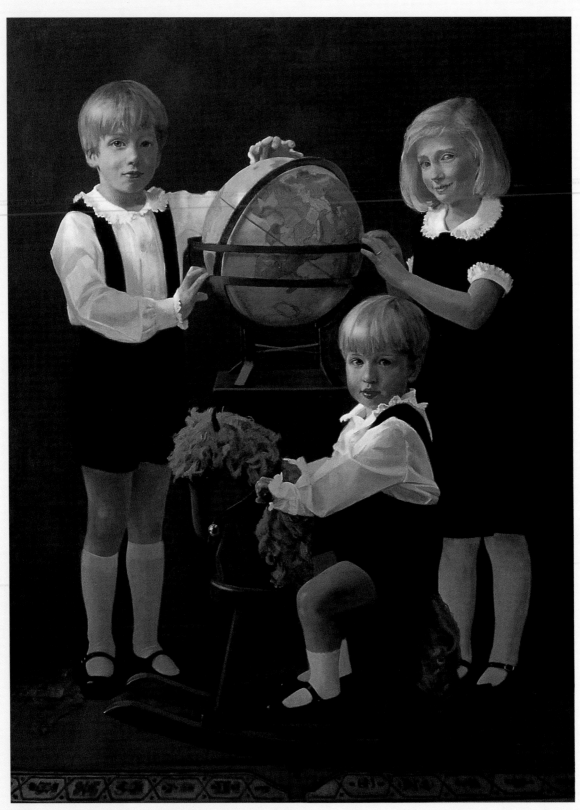

24

As is well known, kids under six don't sit still, and for me, who delights in subtle control, they represent a diversion, especially when they come in clumps, beautifully dressed. *The Reed Children* **(24)** is based on selections from more than a hundred photographs that I took in my studio. In composing a picture like this, my first interest is in seeing how the children interact with each other and with me, no parents present. I found these kids to be rather independent, the older two eager to share their knowledge and the youngest sleepy from a nap but curious. They came with a carload of props, Christmas new, from which I chose the globe and the hobbyhorse.

The basic compositional idea was to group the children cheerily engaging the viewer against a dark background of limitless space, their world clearly in the center. The hobby-horse on the (magic) carpet gives the whole a nice touch of instability, as if they all might rock. I took bits and pieces from different photographs—each child had posed independently of the others as well as together—and gradually this design evolved. The left sides of each of the three heads, the strongest contrasts in the picture, are of roughly the same size, leading across from the older boy to the girl down to the youngest. Each is isolated and yet they touch. It is a carefully arranged still life of beautiful children, the impossible dream.

Composing has to do with taking the viewer on a trip around a picture, with delights along the way and a final destination, a focal point of highest contrast. The bigger the picture, the more necessary composing is. In *The Reed Children* I hope it comes down to the youngest child's right eye.

In *The Great Conversation* **(25)** the focus is the turtle's head, the brightest spot in the picture, but other factors weigh in. This little beast is offsetting the weight of a big bronze Buddha (as he might in symbolic conversation with the universe on his back). Connecting the highlights from the Buddha's forehead to his right hand to the turtle is a centered diagonal; the left hand almost defers majesty as it deflects attention. But the real eye-mover in this picture is the Buddha's downward glance of serene resignation.

I don't really think about all these things when I compose my pictures; I see them happen. Most decisions are instinctive. They feel right, or wrong. When I read a good art-historical analysis of some familiar masterpiece, I am always amazed by the profundity of the artist. Did he or she really think all that out? Is everything a conscious communication? Is the viewer actually aware of these brilliant subtleties? Art-historical analyses humble me. My work reflects my taste as much, if not more, than my intellect. How bright I make a color has to do with what I think and feel looks good, not with the symbolic nature of the hue or with grabbing someone's attention. "Taste" is a tough word, because it has so many meanings. "In poor taste" suggests social judgment; "our tastes differ" is about personal preference; while "tastes change" describes trends. In all of these examples, taste is fickle. But in the sense of arranging things to stunning effect—"she has great taste"—it can transcend fashion and time. Bringing many different things together, such as colors, forms, edges, and brushstrokes, so that there is a unity of purpose, a personal totality, is very difficult. Taste, in this sense, is the partner of talent; they are lost without each other.

There is no end to all this. The handling of the materials, the choices and preferences are important; decisions must be made. Technique is not second to talent and taste; it is the means of expressing both.

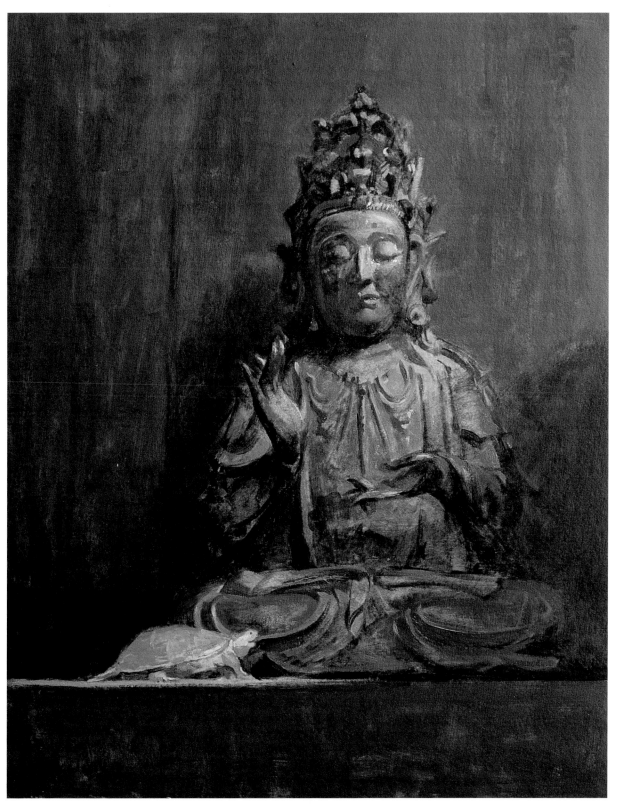

25

I made the composition diagrams **(26)** on these pages for a class in Germany that had a particular interest in landscape painting.

COMPOSING

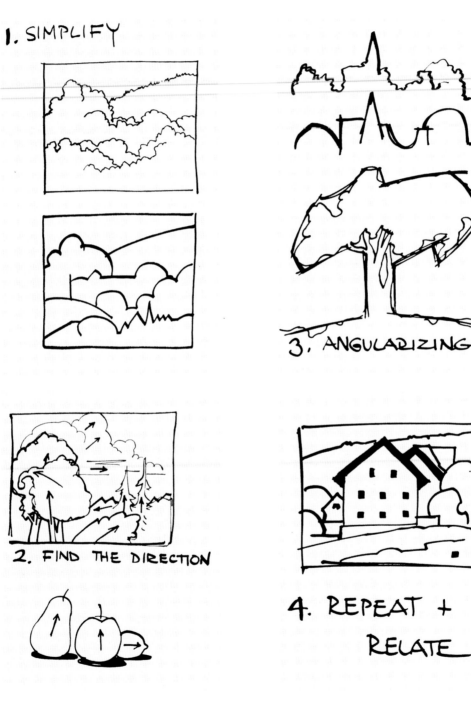

1. SIMPLIFY

2. FIND THE DIRECTION

3. ANGULARIZING

4. REPEAT + RELATE

5.

USE VERTICALS

+ HORIZONTALS

7. FOCUS ATTENTION

THE DARK/LIGHT DESIGN

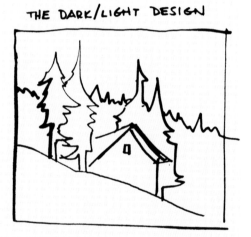

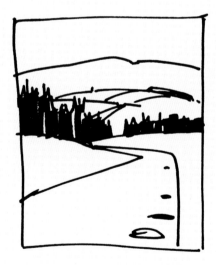

6. LEAD THE EYE

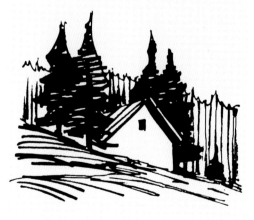

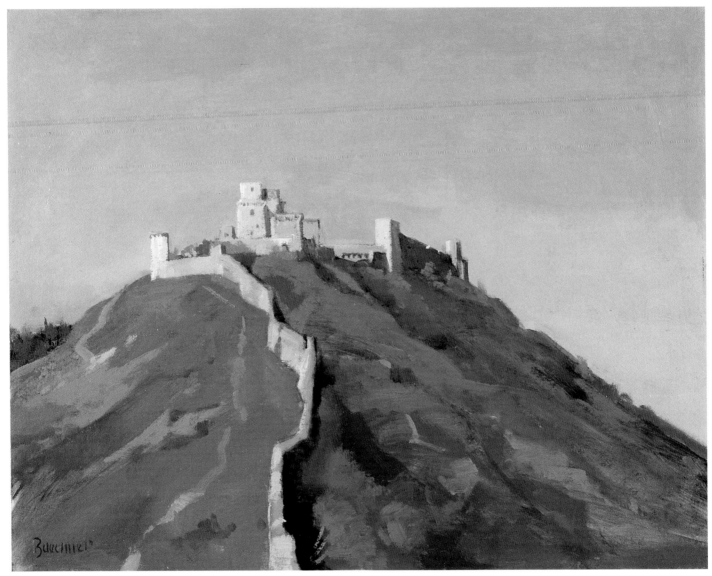

27

Making Space

The simplest way to make space is to put one brushstroke on top of another; the second stroke is nearer to you and it *looks* nearer. The ancient formula for what to paint from start to finish is to go from back to front: the background or the sky first; then the mountains, the trees, the house, the plough; and finally the foreground weed patch. The nice thing about this system is that no edges have to be saved. If I don't follow it, and paint the mountains first, I have to be careful not to disturb them when I put in the sky. I would rather take up the oboe than paint sky around the bare branches of a tree in a winter landscape. The system works best when I get everything right the first time, which is extremely rare. Corrections and changes affect the luminosity of the paint layer and show up like cement on marble, but this sequence does make sense and I am happy when I pull it off **(27)**. Sometimes I reverse the sequence and paint the background last, because I can emphasize the silhouette of the main subject in a very stark way **(28)**.

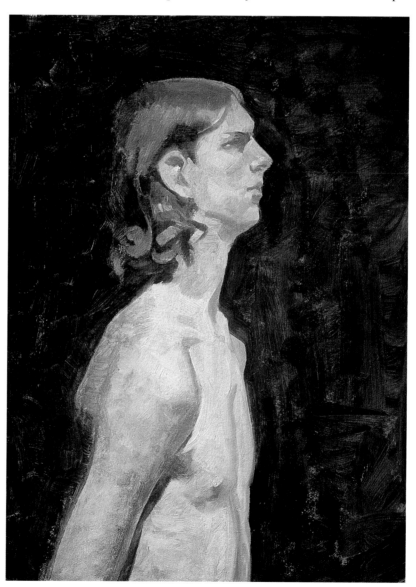

28

Linear Perspective

The only art course available at my high school in 1943 was mechanical drawing, which should be mandatory nationwide. We learned how to think about objects as if they were flat abstractions—front, side, and plan views with dotted lines for the invisible. We used dividers to plot the points of an ellipse made by truncating a cylinder, and we connected them with an elegant piece of plastic called a French curve. We inked straight lines with triangles and T-squares on linen, using pens that could be adjusted for different widths. From these drawings beautiful blueprints could be produced. A machinist could have made the objects that we drew, and our drawings were all identical. In theory, we could take anything in the real world and put it on a piece of paper so that it could be reconstructed exactly. Mechanical drawing is all about measurement. I liked the abstract precision of it but not as much as I liked what came next: perspective. It was the crescendo of the course, using measurement to create an illusion of reality. With the same flat views—just two of them—any place, inside or out, and any object, tiny or immense, could be drawn in perspective and made to look three-dimensional. Another splendid thing happens with this mathematical miracle: the location of the plane (the piece of paper) on which the perspective is drawn *and* the location of the viewer are revealed.

Thus, I have to decide before starting to draw where I want to be and where, in the space between me and the subject, I will locate the picture plane. If my subject is a house, will I look up at it from the street or will I look down on it from a taller building? Will the picture plane be close to the house or far away? If the subject is a person, will she be below me or above me, far enough away so I can see all of her or so close that only her head will show? Consider the possibilities. With enough accurate measurement, I can make a fly look as big as a football stadium just by putting my eye level at its feet and the picture plane as close to the insect as possible. As a child I used this great gift from the Renaissance (the Romans didn't know about perspective) to draw endless rows of soldiers, swooping P–40s, army tanks looming over Nazi bunkers, exploding buildings. I use it now to make grand villas grander (29) . . .

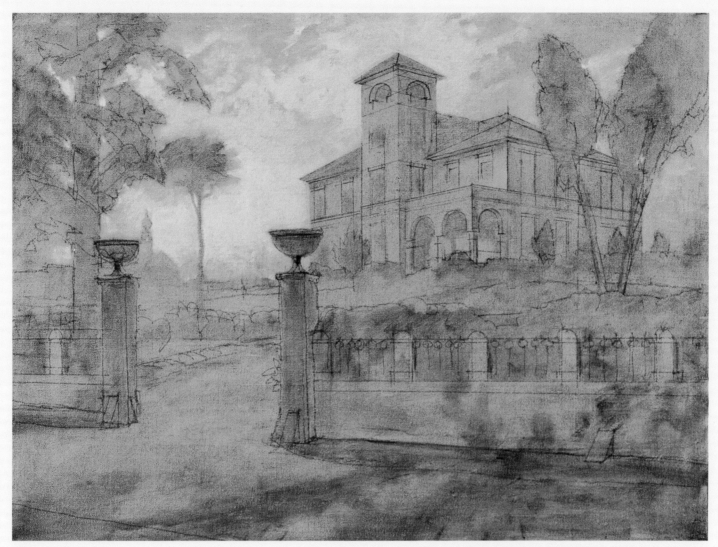

29

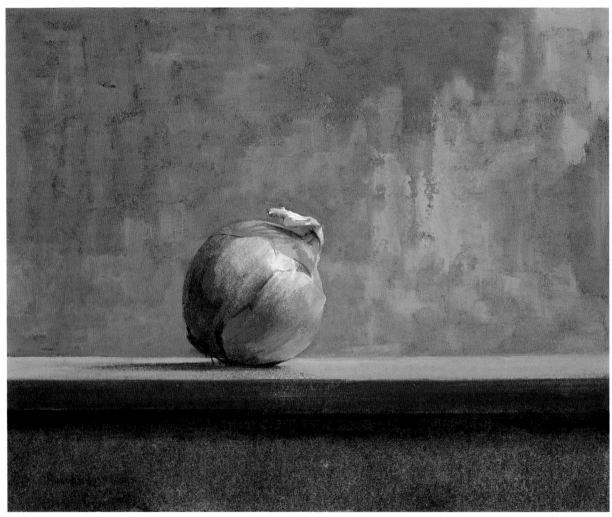

30

or onions as monumental as they are **(30)** . . .

and to lead the viewer into a portrait **(31)**.

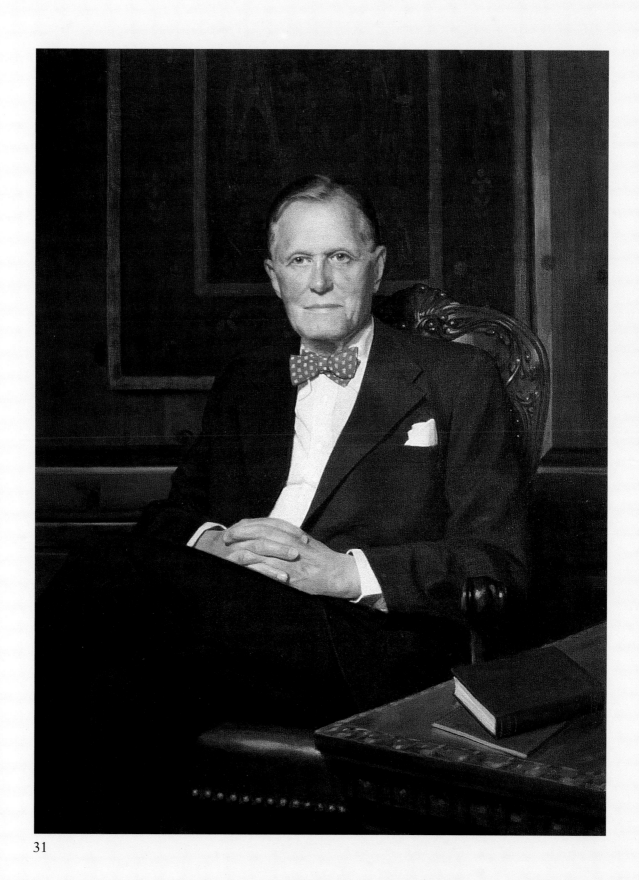

31

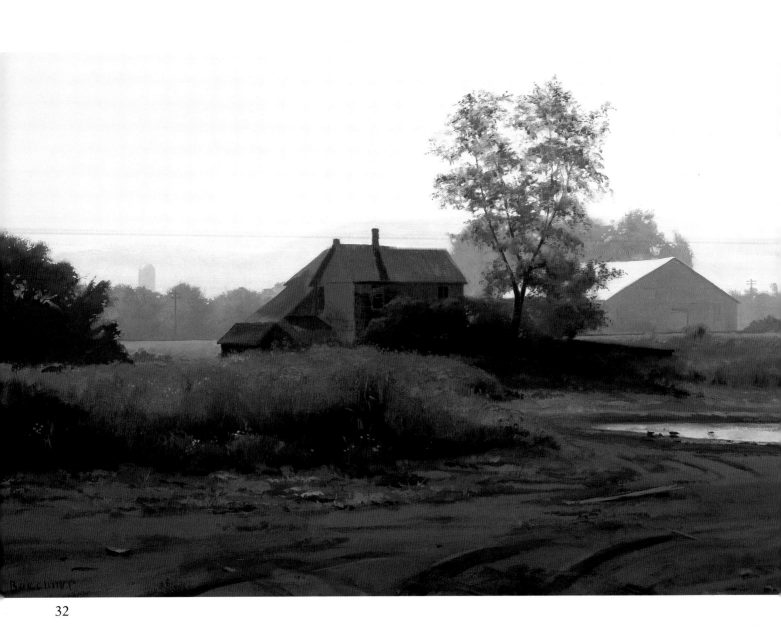

32

Perspective is about making space and putting things in spaces, but it does not have to be complicated or purely mathematical. There are plenty of good books on the subject, many of them written especially for artists, and they often contain useful information on such topics as how to cast shadows and what the laws are that govern reflections. (I have listed my old favorites in the bibliography on page 115.)

I value what knowledge I have in these areas, not so much because it helps to get things right, but because I can use it to manipulate what I see in order to convey what I want. In *Yellow House* **(32)**, perspective, cast shadows, and reflections have been arranged to

emphasize the heat of a muggy summer day in Big Flats, New York.

Light and Shadow

Perspective is linear, but in nature there are no lines, only edges, which are more or less visible depending on the light that falls on them. Light is the key; it determines everything. Without light there is nothing to be seen, and this is where shading and casting shadows come in. I learned this before kindergarten, when I first started with

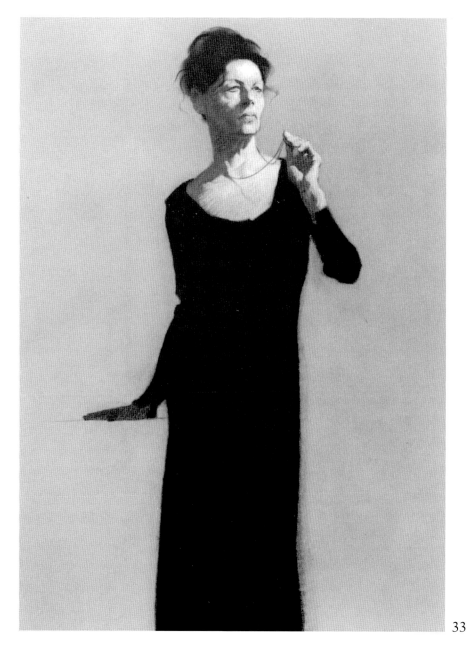

33

coloring books and crayons. If I pressed the crayon lightly, the color was light, and the more I pressed the darker it got. Flat things could be made to look round by starting lightly on one side and getting gradually darker until the paper was shiny with wax. When I was old enough for the sketch class, I learned to cover the whole paper with a dark smudge of charcoal and then to erase the spots where the light hit the model. Later we switched to tinted papers and chalk because the range of tones was greater and more subtle **(33)**.

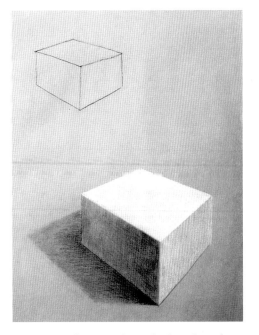

Perspective locates edges; shading describes form under particular lighting conditions

Shadows indicate the direction of the light and describe the surface on which they fall

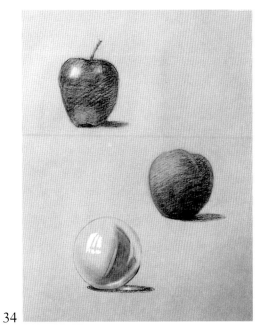

The way light is reflected describes the surface texture

In the lower tree, light is reflected up from the ground

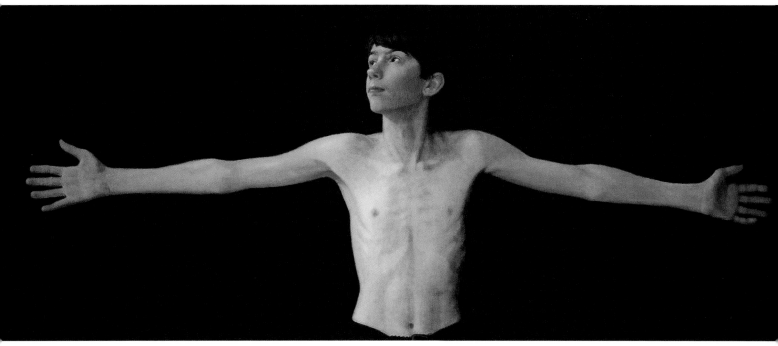

35

Rendering light is not simple because it always varies in intensity. Light is brighter near the source and also if it bounces off something shiny, like a windshield. Light gets lost in black velvet. More light jumps off the ground in Arizona than in New York. And the shadows it casts can be filled with light from a bright blue sky or be inky black in the light of the moon. These clever shadows can describe the forms that cast them, the surfaces on which they fall, the distances between things, the source of the light and whether it is diffused or concentrated or over the yardarm **(34)**.

"Chiaroscuro," the Italian word for painting in bright light and dark shades, is really about building dramatic space. Figures emerge into the light from vast empty darks, and they claim our attention as if they were alone in the universe. By emptying all visual information out of the shadows, we can heighten the impact of the limited tonal range of paint and actually portray a void, a subject without context **(35)**. Powerful stuff.

AERIAL PERSPECTIVE,
OR THE EFFECTS OF AIR

THE ESSENCE OF
PERSPECTIVE

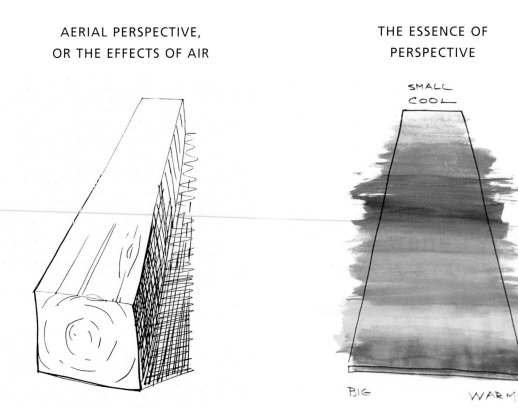

36

Aerial Perspective

Blue appears to go back, red and yellow to come forward; cool colors recede, warm colors advance. Distant mountains look blue or purple or gray—cool. This phenomenon has to do with moisture in the atmosphere and the way light bounces around. Known as aerial perspective, the cool-warm relationship is the best tool we have for making space, from the depth of a shelf to the expanse of an ocean. I use aerial perspective three ways. I put the yellow, orange, and red parts of the spectrum in front of the purple, blue, and green parts wherever I can. I add white to any color, in order to make it cooler. I paint dark colors over lighter ones, which makes them appear warm, and light colors over darker ones, which makes them appear cool. I learned most of this last technique by copying the nose of Rembrandt's *Noble Slav* in the Rijksmuseum in Amsterdam under the scrutiny of M. M. van Dantzig, my teacher. Rembrandt's underpainting in various shades of brown and white affected the colors painted over it. This was a revelation to me. Because noses take up very little space, it's easier for me to explain this using a landscape **(37)**.

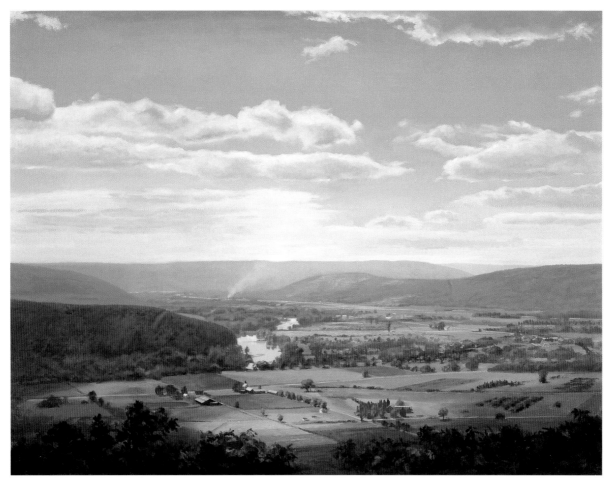

37

For this picture I covered a single primed white canvas with a thin, transparent layer of raw umber (imprimatura), let it dry, and painted the scene from the horizon down, using washes of raw umber that got darker as I came toward the foreground. So much for the underpainting, all in raw umber. The sky and distant hills were then painted with colors *lighter* than those underneath (light over dark is cool, cool colors recede) and the foreground with colors *darker* than those underneath (dark over light is warm, warm colors come forward). Eventually, the blue of the sky became darker than the raw umber underneath and softly turned from cool to warm. (A thin, light layer applied dry to a darker dry layer beneath is called a scumble; a dark layer applied wet over a light, dry layer is called a glaze.)

Let's go back to Rembrandt's nose. The colors, turning from warm to cool and back to warm again because of what they were painted over, helped to model the form, to make it come forward and look round. In painting people and things up close, aerial perspective is not an issue, but pulling them forward and pushing them back is, and so is making them look three-dimensional. If I can support my dark-light shading by changing the *temperature* of the colors as well, I can make the forms stronger and more solid **(38)**. I can and anybody can. All colors look cool over dark, even red and yellow; all colors look warm over light, even blue. This is the lesson of Rembrandt's nose. It is the secret of the old masters, maybe the most important thing in this book.

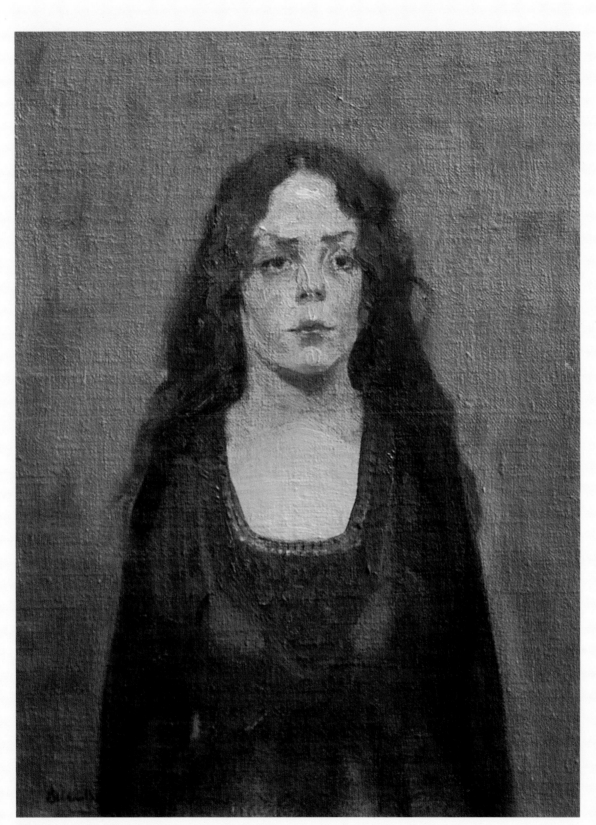

38

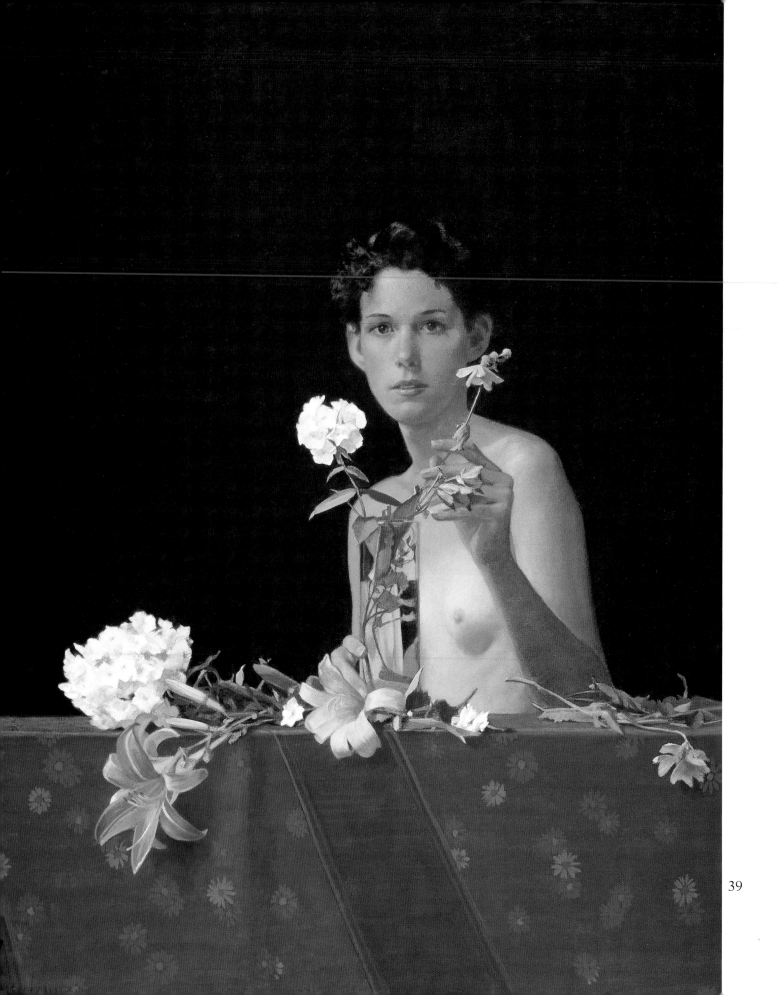

In *Flora* **(39)** the flowers and brown cloth are painted over a lighter tone, while Flora herself is painted over a darker tone. The bright colors come forward, while the cooler flesh tones stay back. All this is relative: Flora is not painted over black but over a raw umber wash that is just a bit darker than her skin colors.

Making space is also about diminishing contrasts **(40)**. Colors lose their brightness as distance increases; darks become lighter, edges get softer, details disappear. A house in the foreground is a dot in the middle ground, invisible in the distance. Even the way the paint is put on can contribute to the illusion of space: thick, brushy, and bold in the foreground, thin, smooth, and blended in the background.

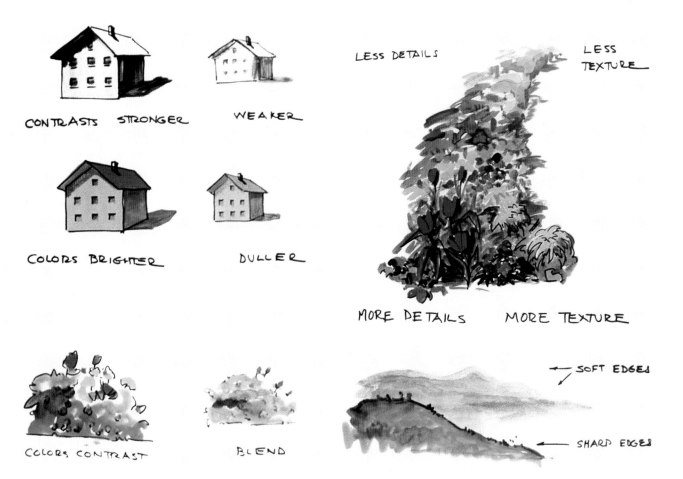

CONTRASTS STRONGER WEAKER

COLORS BRIGHTER DULLER

LESS DETAILS LESS TEXTURE

MORE DETAILS MORE TEXTURE

COLORS CONTRAST BLEND

SOFT EDGES

SHARP EDGES

40

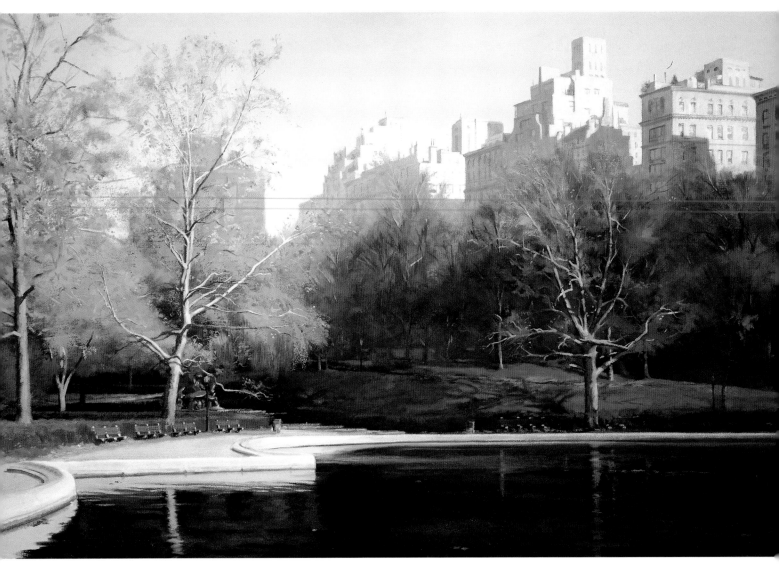

41

In painting the buildings along Central Park in New York **(41)**, I made them progressively cooler and lighter with less and less detail, softer and softer edges.

All of these principles are applicable to still life and portraiture, even to making noses come forward and ears lie back. I try to make any shallow space just as palpable, as tangible, as deep space. In *Little Pumpkin* **(42)** the hard edges of the leaves appear in front of the soft edge of the pumpkin, and in the background the light lavender over the luminous raw umber imprimatura holds the surface back like a theatrical scrim. At least that's what I tried to do.

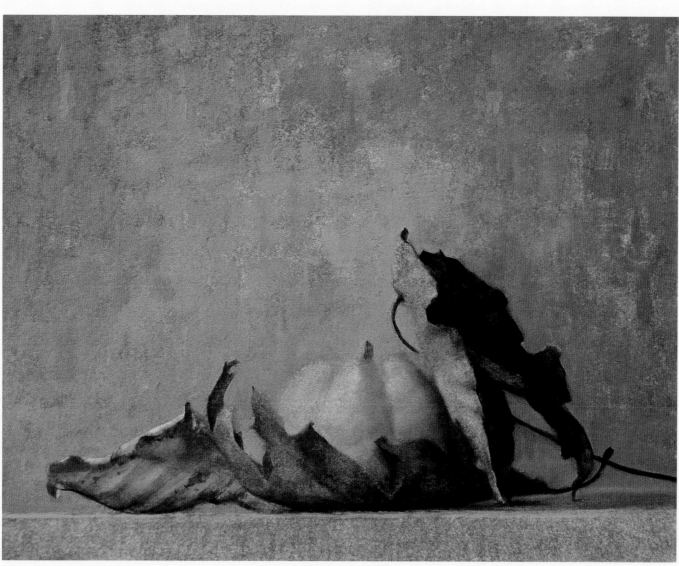

42

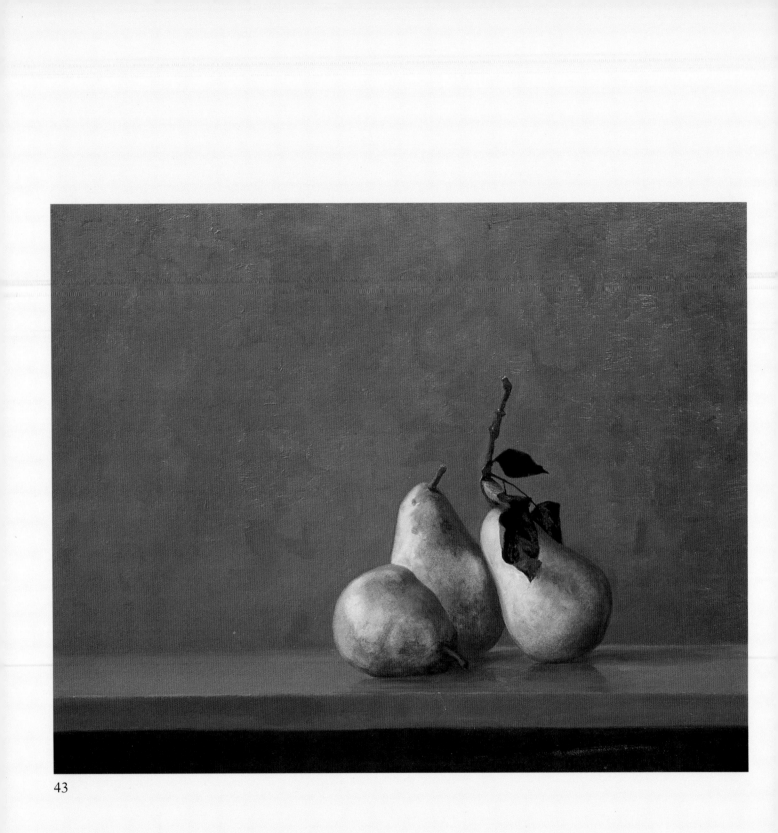

43

PAINTING

Still Life

Figure **43** is a still life of three pears. I made the painting to sell but took photographs at various stages so I could also use it as a demonstration. That's *why* I painted it. What the picture is about is a little more complicated. The pears were arranged as you see them on a shelf in my studio. They looked to me as if they were in a struggle. The one on the right is shoving and threatening; the one in the center is resisting; the one on the left is already defeated. Things can appear to interact just as people do. It is a matter of placement. As the picture gets painted, the characters develop as in a play and the story line itself can change. In this case, it became the triumph of youth over age, and the skins of the pears were treated accordingly.

Using yellow ocher on a very absorbent board **(44)**, I located the pears right of center to allow room for flight (the protagonist is shoving from right to left). The axes of the three pears make a sort of collapsing fan, and the stems describe the state of their aggression from huge club to wilted rod. The picture is to be about a struggle so the location, direction, and spacing of the components should support that idea. These first decisions are the biggest ones.

Colors—cadmium yellow, yellow ocher, sap green, burnt sienna, alizarin crimson, ultramarine blue—are laid on transparently without any white **(45)**. White would dull them; I can't get color brighter than straight out of the tube, painted thinly over the white board, so I lay on the colors at the beginning to get a flat, rich glow. This technique starts out like watercolor: the thinner I apply the paint, the lighter the color, except that here I use thinner and Liquin instead of water (the Liquin also seals the surface and prevents further absorption).

The background is made of ultramarine blue and burnt sienna **(46)**. Once the white areas are covered, I begin to see how the color and tonality are going. Now I take a paper towel and wipe off all the excess paint, being careful to go from the lights into the darks so I

44

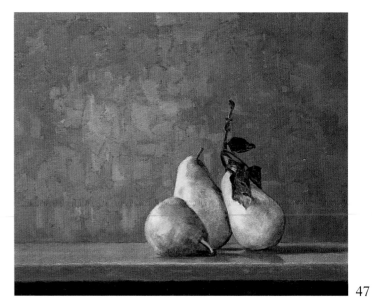

47

45

46

don't streak those luminous yellows with the color of the background. Everything comes off that hasn't soaked into the absorbent blotterlike surface. The leaves are lighter and the original yellow ocher drawing is again visible. This first layer of paint not only stains the surface underneath but also seals it.

For me the most exciting part of painting a picture is to establish and refine the pattern made by the lights and darks. This is when I can see where all the planning is headed, where I can simplify and accentuate. Another background is painted over the first. Made again of burnt sienna and ultramarine blue, this layer of paint does have white in it. It is thick and dull, which makes the yellows look bright by comparison. It is also a covering

layer, so that the shapes and edges can be adjusted. I let little patches of the first background show through to liven up the monotony of the gray and to suggest the existence of another plane. The darks in the pears and leaves are reinforced with transparent colors to keep them luminous **(47)**.

Finally come the small color touches—the green on the leaf, pinks on the stem—and a big, thick, opaque light of cadmium yellow and white on that aggressive pear, providing the highest contrast in tone, color, paint texture, and sharpness of edge with the dark of the leaves. After all, painting is about attracting and directing attention through relative contrast **(48)**.

48

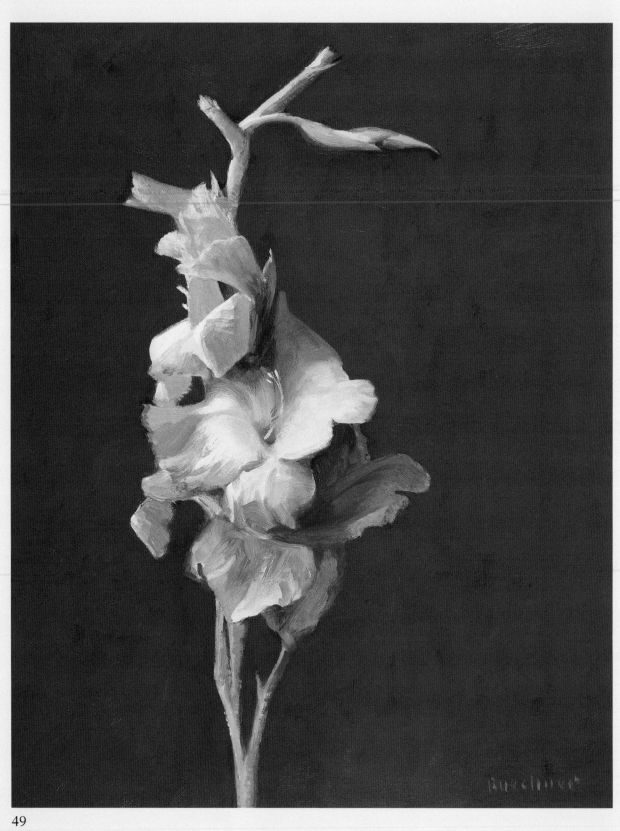

49

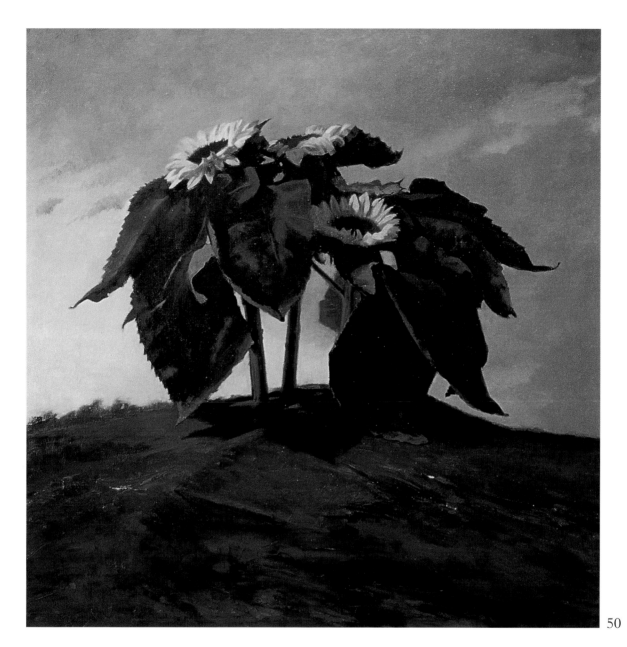

50

Flowers

Although nature loves a spiral **(49)**, most blossoms are based on simple geometric forms, such as disk **(50)**, cylinder, cone, and sphere. A daffodil, for example, is basically a flaring cylinder, the trumpet, set into a disk made up of six petals. Flowers are continuously active but in very slow motion. They unfold from a bud, reach up toward the sun, stretch out their petals to the fullest, and start to diminish. They are living architecture, designed to attract.

I begin by painting the mass of the blossoms on my board with colors as close to those of the flowers themselves as I can find, in this case cadmium yellow light and cadmium yellow medium right out of the tube, made fluid with Liquin. There is no way to get brighter color; adding white will only dull the yellow, and bright yellow is what these daffodils are about. That's their attraction. I define the yellow mass more carefully and do the rest of the drawing in dull green **(51)**.

Using yellow ocher, burnt sienna, and ultramarine blue—no white—I mix up and paint in the other areas, using more or less Liquin to control the transparency of the color. The fabric in the foreground is made with the same paint as the background, except that more medium has been added to make the paint thinner so more of the white board shows through **(52)**.

Because this board sucks up paint like a blotter, I have a dry surface after wiping off the excess paint and can shade the flowers using yellow ochre with a touch of blue in the darkest parts. The serious darks, the background, come next and I use the same paint, a little thinner, to round the vase and darken the stems. Still no white. This is the fourth opportunity I have had to refine shapes and edges **(53)**.

Finally, I use yellows mixed *with* white, for the lightest parts of the flowers, and I cover the background with a slightly *lighter* dark (made by adding yellow ocher to the mix of burnt sienna and ultramarine blue) than the one underneath. This makes the background duller so the flowers look brighter by contrast **(54)**.

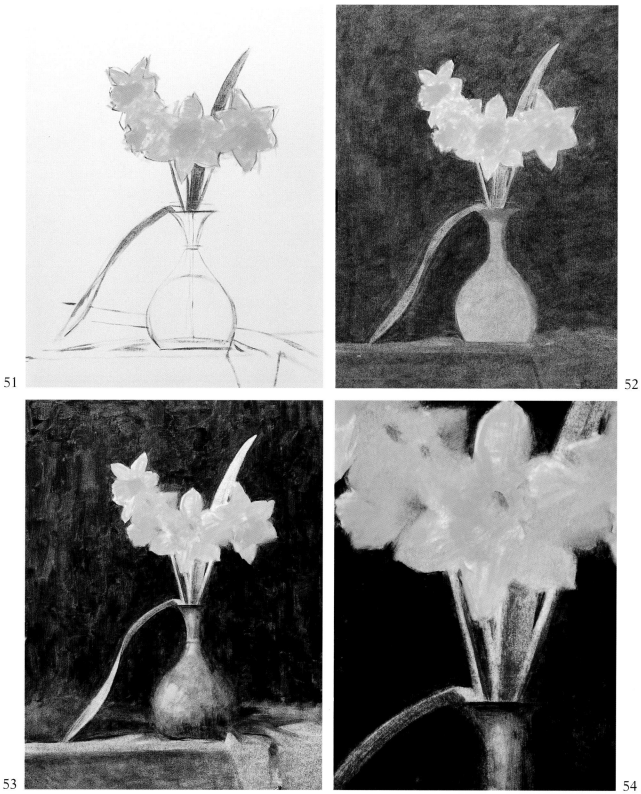

51

52

53

54

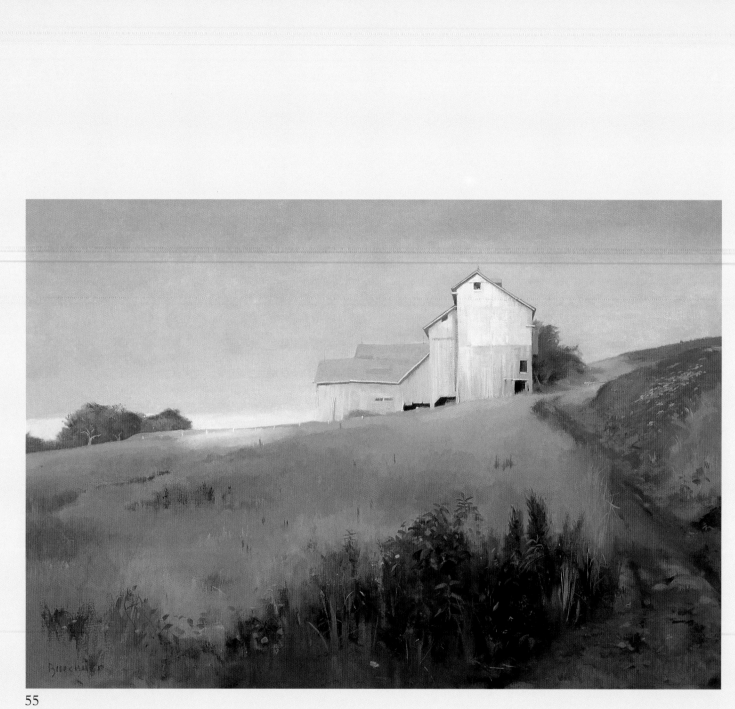

55

Landscapes

There is a barn in Caton, New York, that I have painted dozens of times over the past twenty-five years. The barn hasn't changed much, but I see it differently each time I go out there. Sometimes it's cheerful, a happily haunted survivor; sometimes it is morose, alone, the last of its kind. It's like visiting an ancient relative, I never know what I'm going to find. The five pictures reproduced here **(55–59)** were done years apart. The roofline and the sloping hill are common to all five, and I used those elements to organize the space, drawing with a brush, locating dominant contrasts, doing the geometry.

Before going out to paint the barn, I had already put an imprimatura (a transparent middle tone) on the white surface, canvas or board, which gave me several advantages. I could paint lighter as well as darker, and, without the glare of a white surface, I could better judge the values, the relative darkness and lightness of the elements in my picture. Also, the transparent, luminous color of the imprimatura contrasted nicely with the opaque colors to be painted over it. The next big set of decisions was about the lights and darks themselves. In **(56)** and **(57)** I put the earth and barn in strong silhouette, dark against the sky. In **(55)**, **(58)**, and **(59)** the darks float in a middle tone. Verticals play an important role in all five paintings. They stand for the man-made within the loose chaos of organic shapes, and they point up the lines that lean. These pictures are literally about the weather, the season, and the time of day, but abstractly the colors and shapes establish the mood. No subject ever looks quite the same, nor is a painter ever in exactly the same humor when he or she looks upon it.

Pictures **(56–59)** are field studies, all done out of doors in the presence of the subject. Each took less than three hours; light changes too radically to take longer than that, and the scene is not the same. By painting on a very absorbent surface with Liquin and fast-drying alkyd paint (which is compatible with oil), I can choose the color for my imprimatura right on the spot and I don't have to do it beforehand. If a landscape is made up of summer greens, I may use a reddish tone to complement the green paint that will come on top, or purple-browns to complement yellows, earth green for pinks, and so forth. What I sacrifice in this process is luminosity in the light areas. The white surface has been darkened by the

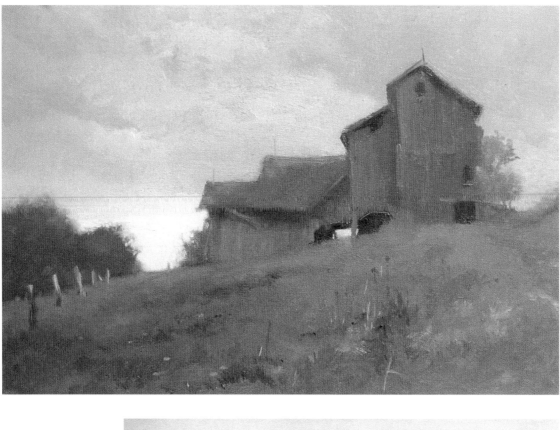

56

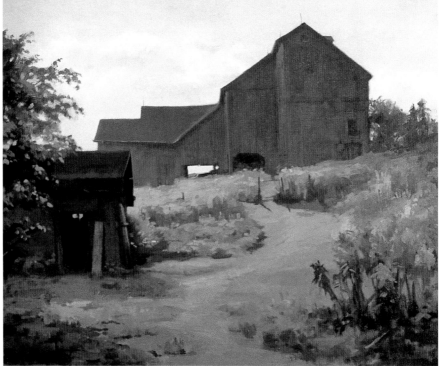

57

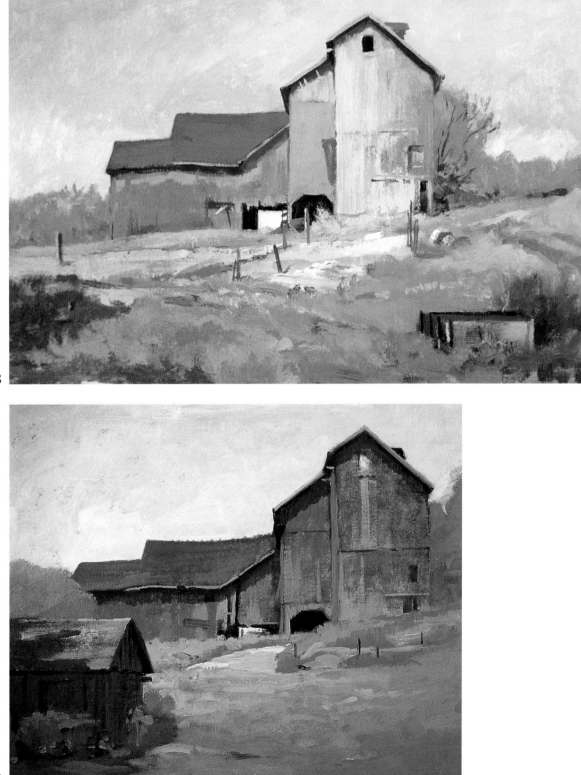

58

59

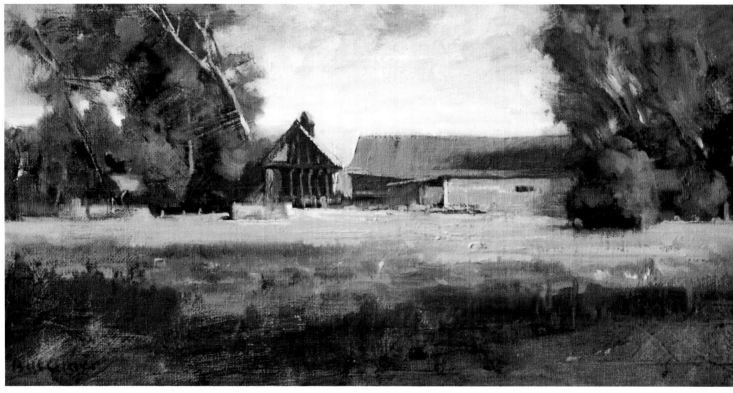

60

imprimatura and no longer lights up colors that are lighter than it is. This gives me a chance to work with thick lights and heavy paint texture with the colors underneath glowing through.

The term "field study" implies preparation, doing the homework before launching into a major effort in the studio. Plein-air painting, on the other hand, is an end in itself; it simply means painting outdoors. That is usually what I do, making two paintings a day, sometimes three, when I am on the road. I try to make nice little pictures and I hope

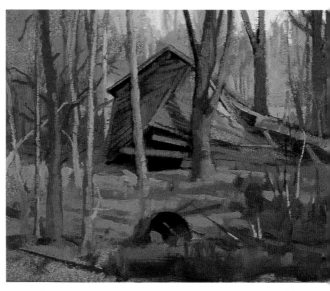

61

they will sell, but the real reason I am out there is because it's fun. I am with a painting friend or two, the weather is good (or I wouldn't be outside), we are in some beautiful, maybe awesome, place doing what we most enjoy: recording and rearranging the world (60).

I have done many hundreds of these paintings, usually on boards 1/32-inch thick so they don't take up much storage space.

Once in a while an outdoor painting turns into a studio production. I see some thing or place I really want to make my own, but that is often impossible in the face of reality. The subject is too seductive, too much, too beautiful, and there is never enough time. Back in the studio, the picture itself dominates. I have my field study and my photographs for information, and from them I can make a place the way I want it to appear. In the woods not far from home I came upon a house that had collapsed. Trees had grown up all around, framing the splayed-out siding like columns around a shrine. I set up my box and did a little picture **(61)**. The recollection of that place haunted me, no life left, nature providing the classic verticals, man's ruin, the baroque. So I did a big one **(62)**.

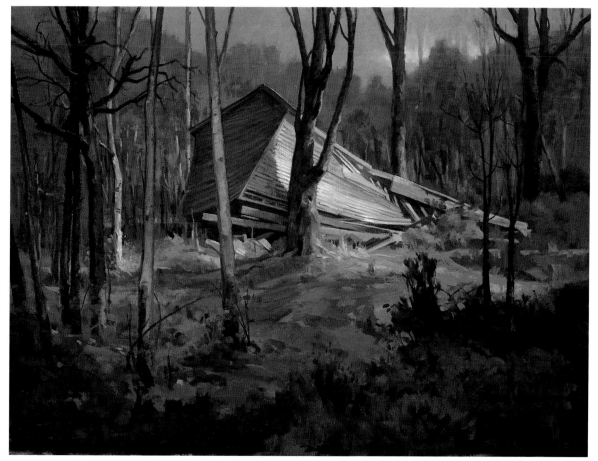

62

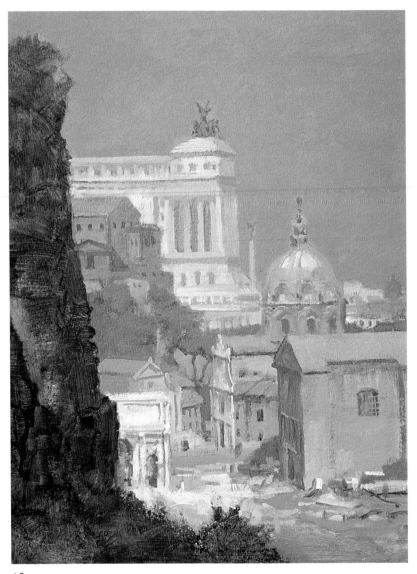

63

Sometimes a subject is just too complex for a small format and a couple of hours of painting time, too complex in the sense that the parts are too rich to generalize. The view of the Roman Forum from the Farnese loggia is such a sight. I was jammed in against the balustrade, trying to keep out of the rain, while the teenagers of the world checked out my progress. Nothing inspires like Rome, so when I got the field study **(63)** back to Corning, I blew it up **(64)**.

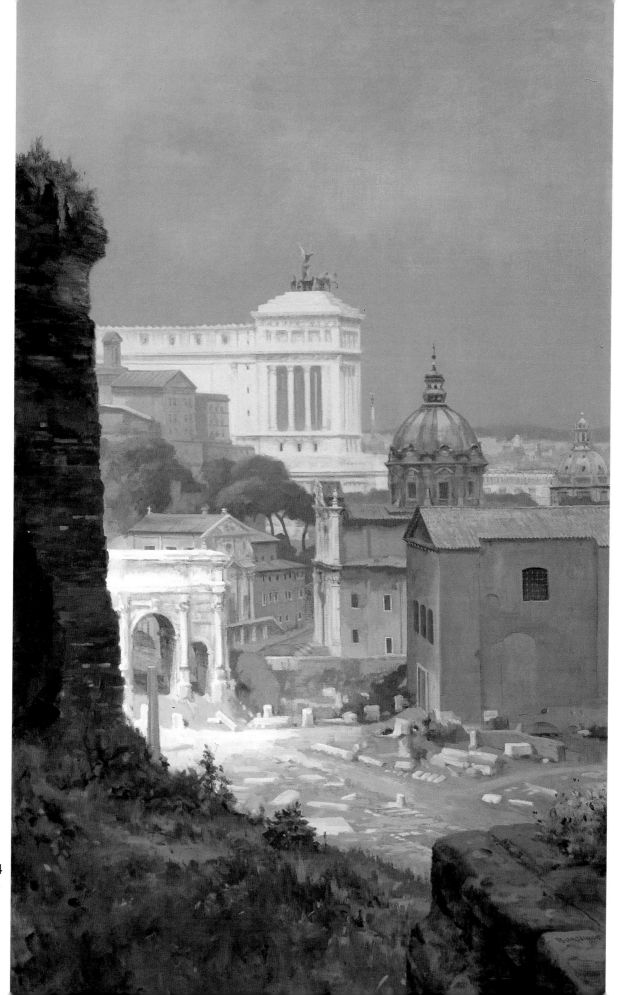

64

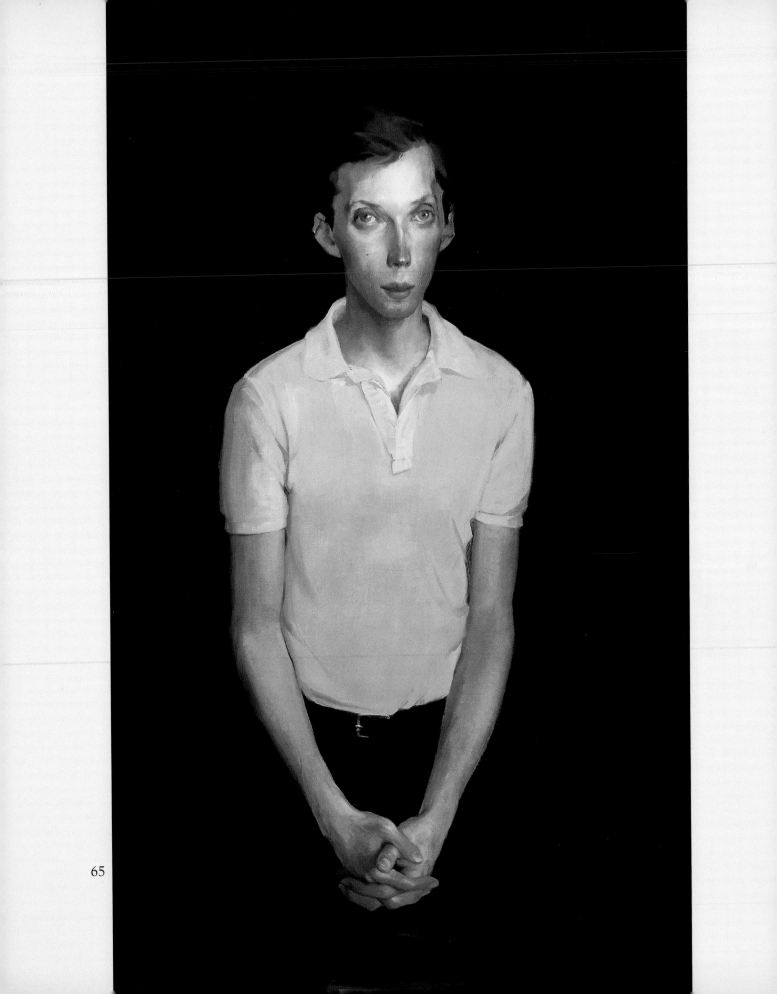

People

There is a difference between painting a model and making a portrait: I choose the model but am chosen for the portrait. *Bill* **(65)** is an old friend who posed at my request. I put his eyes too far apart (like a chicken's) and sharpened his nose (like a fox's) to get this particular look, liberties I would not take with a portrait commission.

A portrait starts with a customer. I perform a customized service for one or more people who like what I do and who pay me one third in advance. My job is to please them, and myself. It's a task I enjoy, almost always, and it can be very challenging. One painting I made of a family with six children took so long that they had a seventh and I had to take the dog off the couch to make room.

I think portraits fall into two general groups: those about a moment dominated by a person and those about a person for whom time has been stilled. John Singer Sargent epitomizes the first and Jean-Dominique Ingres the second. One is an impression, the other an encounter. I work away at the second approach because it lets me focus on one thing at a time. By separating line, form, and color into three distinct stages, I can concentrate on each independently of the others: the drawing first, the dark-light design next, and finally, the color system.

What must come before anything else is the idea for the picture. I start by trying to figure out what the client wants. Sometimes I have to figure out who the client is—the subject or the spouse or the parent—and who really makes the decisions. People rarely know what they want, but they often know what they *don't* want. I try to get as much information as I can, including favorite snapshots. (These describe the client's tastes and preferences, as well as the subject in action.) Ideas begin to form, and by the time the first posing situation comes along, I am prepared to try out a concept or two.

It is nicer to look up to people than it is to look down on them. Our respective eye levels are as important in portraiture as they are in life **(66)**. Most painters, including me, stand when they paint portraits from life. This is so because we move back and forth, both to judge the progress of our work and to observe the sitter at close range and at a distance. But the image

itself depends on a single fixed point of view; if I stand to paint the head and sit to paint the hands, the perspective will be faulty. The same is true of the sitter whose position must also be fixed (which makes sitting pretty boring but standing even worse). I solve this problem by putting the sitter on a high stool or chair on a model stand that measures four-by-four feet and eighteen inches high, the height of an average dining-room chair. This brings artist and model to about the same eye level. We see eye to eye. For sitters as small as the Reed children **(24)**, I will still be looking down on them, even though they are on the model stand, but not as far down as if they were on the floor. The eighteen-inch elevation gives them a presence kids don't usually have. By the same token, a tall person will be above my eye level, which is

WHERE'S MY EYE LEVEL?

LOW FOR
IMPORTANT
PEOPLE

HIGH FOR
KIDS

STRAIGHT ON
FOR SINCERITY

AND THE ANGLE OF THE SITTER'S HEAD?

LOW = SEXY

HIGH = ALOOF

3/4 STRAIGHT

THE BIGGEST SHAPES

ARE THE MOST IMPORTANT

66

67

an average sixty-six inches off the ground. Our culture has traditionally put important people "above" us, but if this is carried too far, we look up their noses, rarely a flattering prospect.

The way we carry our heads is both individually characteristic and a major statement in body language **(67)**. It is also very subtle. I ask questions, make statements, request expressions ("look surprised, angry, serene"), and see what happens **(68)**. Are they frontal or seen from a seven-eighth or three-quarter angle? How do their eyes work? **(69)** What do they do with their hands? What do the wrinkles in their clothes tell me about how they move? All these things help to finalize the idea for the picture and, consequently, the pose.

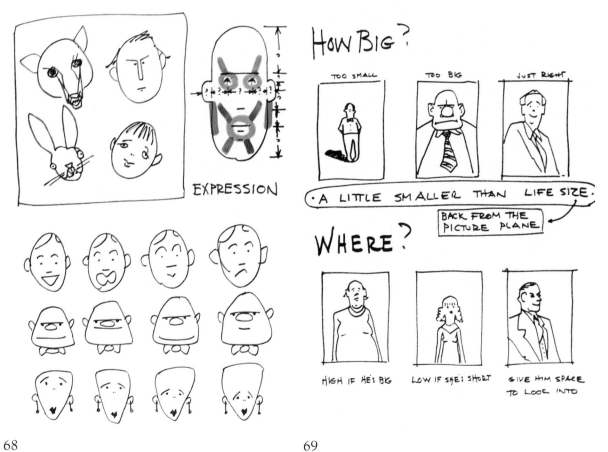

68 69

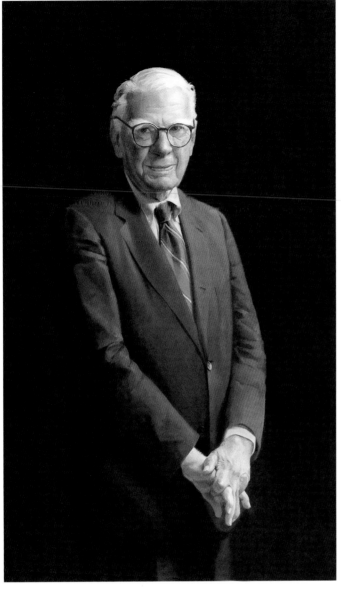

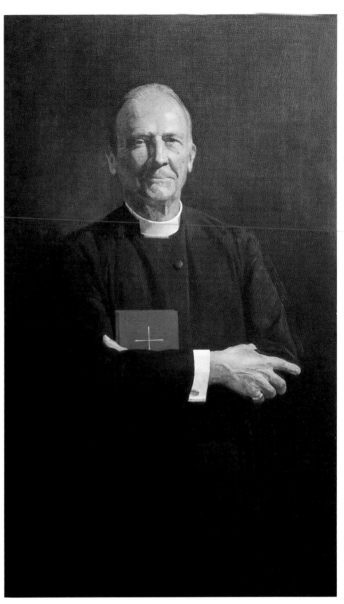

70

71

These four men are as different in their body language as they are in their features. The likeness begins with the silhouette (70–73). If there is a background or a setting in one of my portraits, it is usually there because the client asked for it. I tend to put the sitter, even children, alone in dark, empty space. It is such an unusual circumstance not to be surrounded that the stark background both startles and focuses attention. You see only the person. We are, each of us, quite alone, and that's what I try to paint.

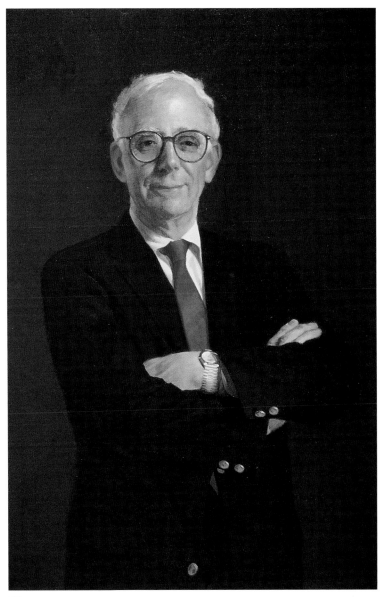

72

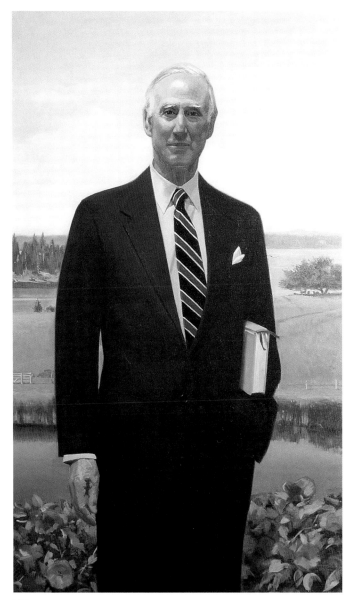

73

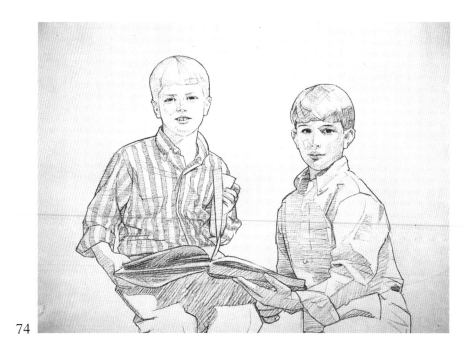

74

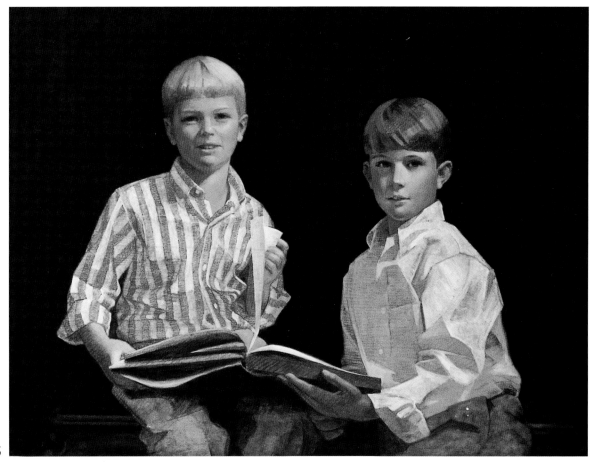

75

This **(74)** is a commission to paint two brothers. The size has been determined, the canvas stretched. Starting with a stick of medium charcoal, I figure out where things are going to go, from large shapes to key details. It is like making a map. I have to get things right—what I know, what I see, and what I want. Charcoal is flexible and easy to erase. When the drawing is finished, I send a photograph of it to the client for approval.

In the underpainting **(75)** I try to do two things: develop the dark-light design and model the forms. If I scrub raw umber over my fixed drawing and wipe it down to the color of brown paper (so the drawing shows through), I can paint over this imprimatura with more raw umber and it will be darker. The lights are built by adding white, thinly where I want it to look bluish and thickly for full light. And there is a little yellow ocher in the skin tone to keep it from looking blue. The middle tones are the brown imprimatura left untouched.

How do you paint the color of skin? In the second grade, Miss Bellows told me to mix white with orange. Since then I have heard and seen many other answers. It is a tough question because skin comes in so many colors and is often translucent so that what is underneath—like blue veins—affects its color. The same is true in painting: the color underneath affects the color on top.

To put it simplistically, Michelangelo painted Caucasian flesh tones over green, El Greco over black, Rubens over yellow, Rembrandt over brown, Reynolds over gray, David over red, Van Gogh over white. The possibilities are obviously endless. Van Dantzig, my master in Amsterdam, started me out with a Botticelli-based system, in which I had to paint pink over green in tempera, using the yolk of an egg as a binding material. This kind of paint dries quickly. The most difficult part was learning to cross hatch, to make rhythmic parallel strokes with a fine brush so that the green showed through a network of pink. The early oil techniques based on Van Eyck and Memling seem easy in contrast, because colors over a light ground dry slowly and can be blended. In *Fletcher* **(3)** you can see the effect of such a ground, whereas in *Willa* **(4)** the skin tone is painted over a greenish brown.

With the portrait of the brothers **(76)**, I mixed up a middle flesh tone of burnt sienna and white, just a bit darker than the light tones in my underpainting. Painting this "skin" thinly over the flesh areas gave me a warm color in the light areas and a cool color in the

87

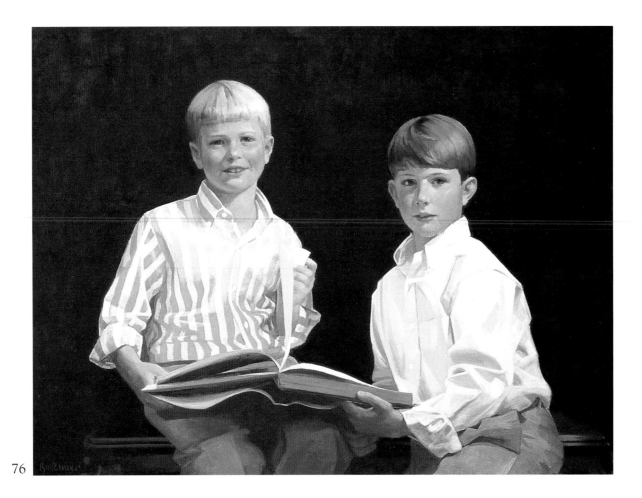

76

darks. This technique is a little like tinting a photograph and can look just as awful if I don't pay attention to the relative translucency and texture of the paint, using more or less of what is underneath. After this step come transparent layers (glazes) of local colors, such as the pink on the mouth and in the cheeks; yellows and greens (scumbles) in the reflected lights and shadows; and finally thick lights (impastos) of white tinted with various colors. I try to leave untouched the tones and colors of my underpainting wherever they will serve.

The trouble with the system I have just described is that it locks me into my original drawing. If anything needs to be changed, lowering the mouth, for example, I must use opaque paint, which creates a dead spot in an otherwise luminous face. Should this occur and it often does, I am obliged to repaint using a range of mixed colors to keep things lively and fresh. I have to leave the fifteenth century and go to the seventeenth (77).

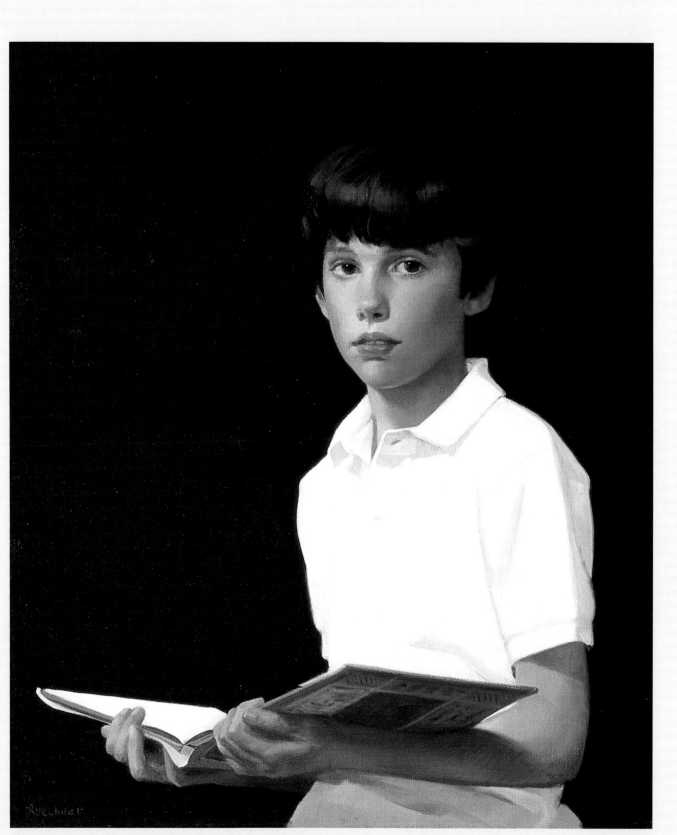

77

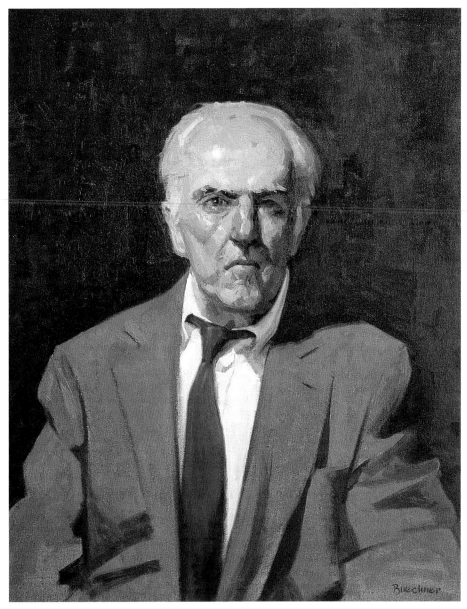

78

The portrait in **78** was painted in a workshop conducted by Daniel Greene. This distinguished artist and great teacher has developed an impressive system based on premixing a wide variety of colors with seven tints of each plus a rich group of darks. The advantage of premixing is that it gives me a lot of choices and plenty of paint. As Dan points out, all I have to do in order to get the right color in the right place is to ask myself: is it lighter or darker, warmer or cooler than the color next to it?

Tamar (Genesis 38) **(79)** is less about variegated color and more about form than **78**. The light falling on Tamar's forehead diminishes as it moves down her face to the shadow under her chin. I painted this face over a green imprimatura using a neutral but very light color, as I did with *Willa* **(4)**. Where the light paint is thickest over the forehead, the ground is completely covered. As the paint gets thinner (and more translucent), the green ground begins to show through and the tone of the flesh darkens. This is a subtle system with a great range of tones. When the light paint was dry, I glazed in bits of pink and other warm colors to heighten, by contrast, the coolness of the skin.

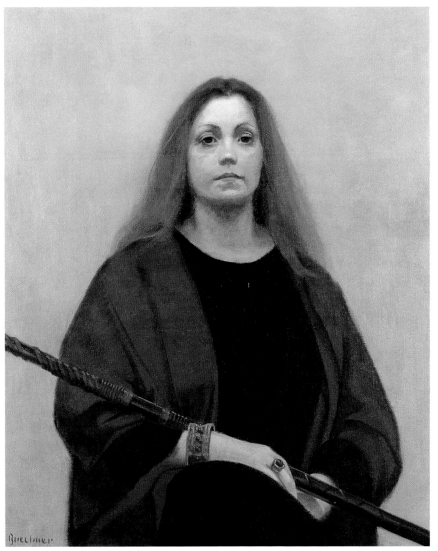

79

DELIVERING PAINT

I subscribe to several auction catalogues and received one recently that included a portrait by John Singer Sargent, whose work I much admire. The portrait depicted was of a man, just the head and shoulders; it was not particularly impressive, but a Sargent is a Sargent, so I went to see it. I was appalled. It looked as if a steamroller had gone over it, crushed it flat, and simultaneously removed the top layer of paint. The hand of the artist was gone.

Painting is accomplished by delivering paint. We do it with brushes, palette knives, our fingers, anything that does the job. We painters make the final product; our pictures literally go out into the world from our hands. Writers need publishers, composers need orchestras, choreographers need dancers, architects need builders, but we do it alone. The paint on a Sargent or a Rembrandt was put there by the master himself. We see the painter, unique in the way the brush moves, the flicks and smears, the paint ridging up under the pressure from the master's hand or a final glaze puddling in the grooves of a slab of paint underneath. Delivering paint is the very life of art.

That miserable Sargent I saw was probably the result of a botched restoration. Too much pressure and heat in relining an old picture will flatten the paint, and too strong a solvent will remove it, along with the dirty varnish for which it was intended. In any case, the portrait was a corpse.

The way a painter delivers paint is as individual as handwriting, only more so because the situation is more complex. If a painter is unsure or hesitant, it shows in the brushstrokes. They may be blurred or buried under others in the hope that they will turn into something. He or she is constantly changing things, a little lighter, a little darker, until the last visible stroke sinks into primal gray. Another painter may display boundless courage but little knowledge by putting strokes all over the place. That painting will be full of energy, but nothing will be quite right. The brush moves but in the wrong directions;

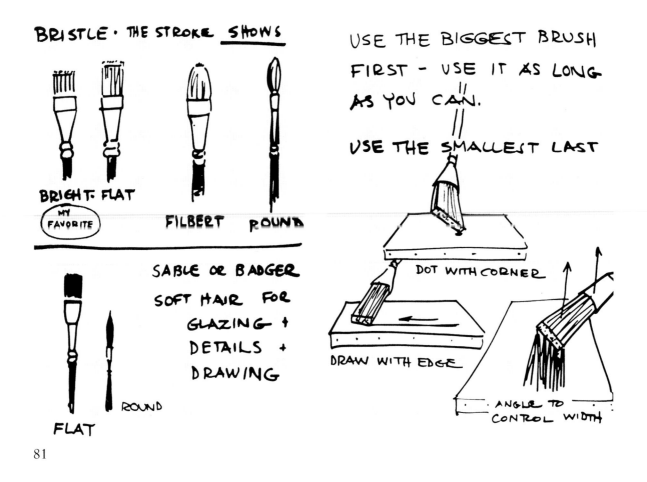

BRISTLE · THE STROKE SHOWS

BRIGHT · FLAT

MY FAVORITE

FILBERT ROUND

SABLE OR BADGER SOFT HAIR FOR GLAZING + DETAILS + DRAWING

FLAT ROUND

USE THE BIGGEST BRUSH FIRST - USE IT AS LONG AS YOU CAN.

USE THE SMALLEST LAST

DOT WITH CORNER

DRAW WITH EDGE

ANGLE TO CONTROL WIDTH

81

the edges are hard where they should be soft, and there is no clarity in the chaos. A painter-mechanic, on the other hand, with a tiny brush in hand, may find details within details, rendering each with identical indifference. The way the paint goes on describes the painter, good or bad. It also describes something that true works of art may have in common: spontaneity.

Spontaneity

M. M. van Dantzig, who was an art historian, graphologist, and psychologist, as well as my teacher, was fascinated by forgery and attempted to separate the genuine from the false in the great Frans Hals exhibition held in Haarlem in 1938. His book on the Vermeers forged by Hans van Meegeren was published in 1947, while I was his student.

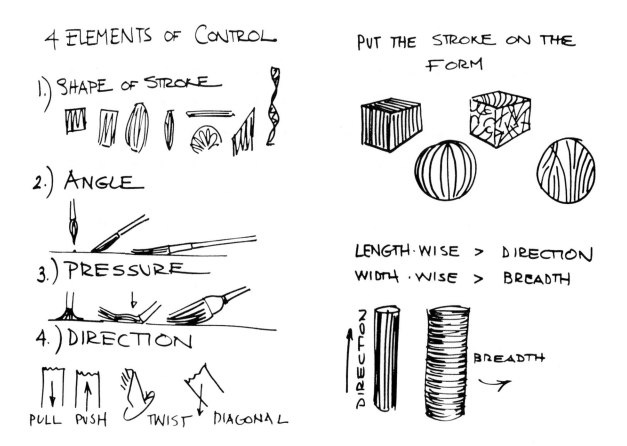

Van Dantzig focused on the painted surface, patterns of color distribution, and brush handling. He had a theory that the creative act must somehow differ visually from the imitative; that it ought to be possible to see the difference between work by someone doing his own thing and the work of someone trying to behave like somebody else. In the pursuit of this idea, he meticulously analyzed hundreds of paintings from Leonardo to Van Gogh, including originals, forgeries, and copies. The result was a complex system for examining pictures, which he called Pictology. At the heart of this theory is the notion of spontaneity.

Van Dantzig came to the conclusion (with many qualifiers) that great works of Western representational art had in common a high degree of spontaneous brush work in areas of major importance (such as the face in a portrait), that the paint was delivered with conviction, instinctively, almost involuntarily, that it was not hesitant, hampered, or mechanical.

Being spontaneous suggests being fast, painting in a great frenzy, counting on the

subconscious to do one glorious, unpremeditated thing after another, all at top speed. The truth is that in painting it only looks that way. We have no idea how long an artist may have paused before making one stroke or many. Perhaps he or she practiced the sequence of strokes in advance or wiped them away, again and again, until they were just right. On those rare and precious occasions when I am really in the grip of the muse, I can be spontaneous *and* fast, but most of the time I organize and reorganize, wipe out and do over. In the typical still life all major contours are reaffirmed several times; contrasts and colors are developed deliberately, level over level, and when at last I really think I know what I am doing, I freely lay on the final brushstrokes, which I hope will be deft and to the point. Spontaneity may occur all through the process, but it is not hurried.

Curiously, spontaneity itself has no value; anybody can do it. A child does so with the first scribble. Spontaneity has to be challenged to be interesting, and the more complicated the challenge, the more wonderful the spontaneity seems. Think of putting a brushstroke in exactly the right place, moving in the right direction, varying the pressure and angle to the surface, trying to represent a fragment of complex reality under specific lighting conditions, attempting to express your attitude toward the subject, *and* doing your best to create a striking image! That is hard. To do it spontaneously is the mark of a master, tangible evidence of a great performance. It is thrilling to see.

Using the Tools

For me, delivering paint began with poster colors, which ran down my sleeve when I painted up high. This led to working horizontally with my face so close to the paper that I could smell the glue in the paint. And then came the first box of watercolors, six disks of color, an impossible brush, and revelation! The more water I added, the lighter the color became. This is a great truth, and it holds for oil painting too: the more turpentine (or mineral spirits or oil or Liquin) added to any color (except white), the thinner and lighter it becomes when painted wet over a white surface **(82)**. Color put on in this way has a sort of glow, because the lighter color underneath shines through the transparent glaze; it is impossible to get the same effect by mixing color with white paint and putting it on opaquely.

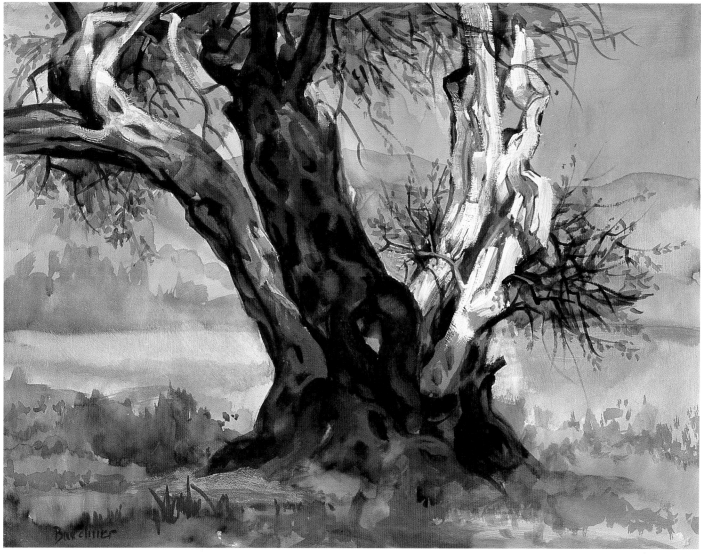

82

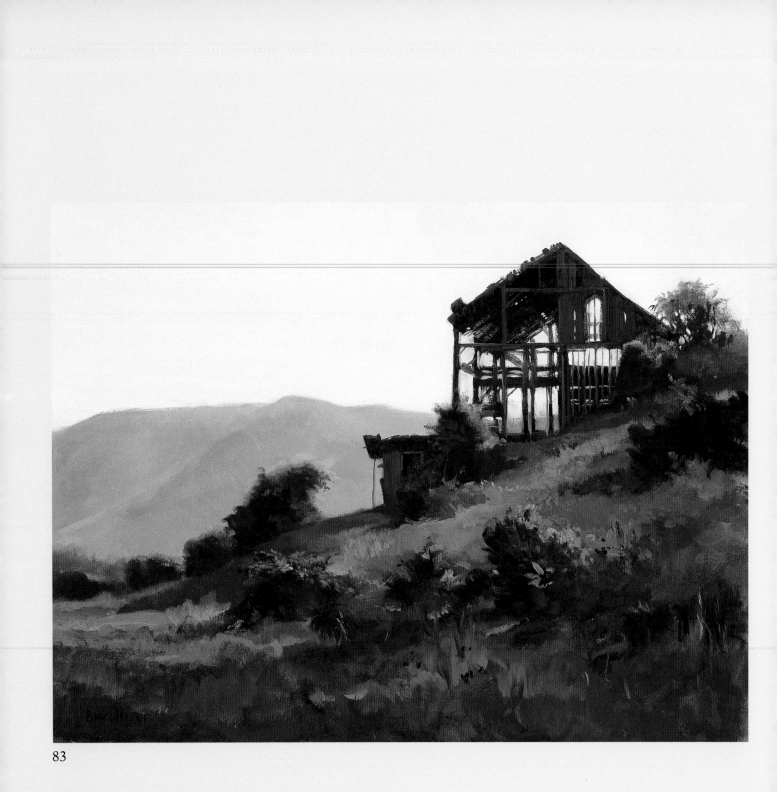

83

I always start with some color put on thinly over white and try to keep some of this luminosity showing right through to the end. It gives me more range and perks things up. The light yellow-green around the bush silhouetted against the blue mountain in *Barn Frame* **(83)** was put on underneath as a wash of yellow. I did the reverse on the mountains behind and painted (scumbled) a thin layer of lighter paint over a darker blue, which killed the luminosity and moved the mountains back (reminder: light over dark is cool, cool recedes). If you look between the posts in the barn frame, you can see what the original blue of the mountains was before I scumbled over it. The omission wasn't deliberate. I forgot.

I like to paint on a surface that has tooth, which is the opposite of slick, but not so much tooth that I can't move the paint around. On the other hand, if the surface is too oily or too smooth (like glass), the paint has nothing to grab hold of and slides off under the pressure of the brush. Another issue is the texture of the surface itself. Canvas, woven of cotton, linen, jute, or anything else, comes in a range of weaves and primings (the layer of chalk and paint that makes it white); panels, cut from various woods and plywoods, Masonite, foam core, or anything flat, can be covered with all sorts of preparations to produce different textures, including even sand and marble dust. And canvas can be glued to panels, as can paper, which presents another huge set of textural possibilities. All these materials have to be protected from the corrosive effects of oil with a layer of glue or gelatin or casein or shellac or polyurethane or acrylic or something, each of which has its own unique texture.

Over the years I have come to prefer a linen canvas, single primed, called Sarasota, which I stretch on heavy-duty stretchers in sizes over 16 x 20 inches or glue to quarter-inch Masonite or Gatorfoam panels for smaller sizes. I also paint on panels covered with Liquitex gesso; these have a variety of textures depending on how the gesso is put on: very thin in several coats with sanding between each for smooth to very thick textures, or with a spatula for rough. I like Multimedia Art Board, which is absorbent, because I am impatient and it gives me two layers of paint, while all the others require drying time before the second layer goes on. Painting over old pictures is especially pleasing. I feel liberated and exciting things happen, with odd colors showing through and an old failure being buried under new paint.

I have come to think of pictures as objects as well as illusions. I want the surface to be rich and variegated and the paint to have a double existence by both portraying something and being nothing more than itself **(84)**. Roman brick nicked with a knife, a rim of light created by a ridge of Naples yellow, scored with a brush handle, tactile and tangible in itself.

Ever since I attended a workshop with Clyde Aspevig ten years ago, I have favored short bristle brushes (brights) in the hope that they would help me paint landscapes like Clyde's. They have not, but they are great brushes because they deliver paint in several ways that I have come to depend on. A bright gives me a thin line on its edge and a broad stroke with the flat side, and everything else in between. When brights are old and beat up with rounded corners, they are good for scrubbing on thin layers, wet or dry. Brights leave their mark. If I must do something very small and exacting, or if I don't want brushstrokes to show and I do want colors softly blended, I use sable brushes. The rounds make good dots, and the flats are perfect for broad, blended areas. But for vigorous work, a hog's-hair bristle bright is best: I can push it into the paint like a shovel, drag it like a rake, splay it out like a fan. Every angle from shoulder, elbow, or wrist requires another range of strokes, and, if I can bring myself to leave them alone, they record my actions in a nice crisp way.

Another great tool for delivering paint is the knife. My favorite shape is shown in **(16)**. I use the knife in two ways: to smear paint into a light concentration like the gray-blue on the trout in **(80)** and to make sharp, thick lines like the yellow on the string. Smearing is done with the flat of the blade and is much affected by the texture of the dry paint underneath. Lines are made by gathering paint on the edge of the knife and then laying it and dragging it along precisely where the line is to be.

84

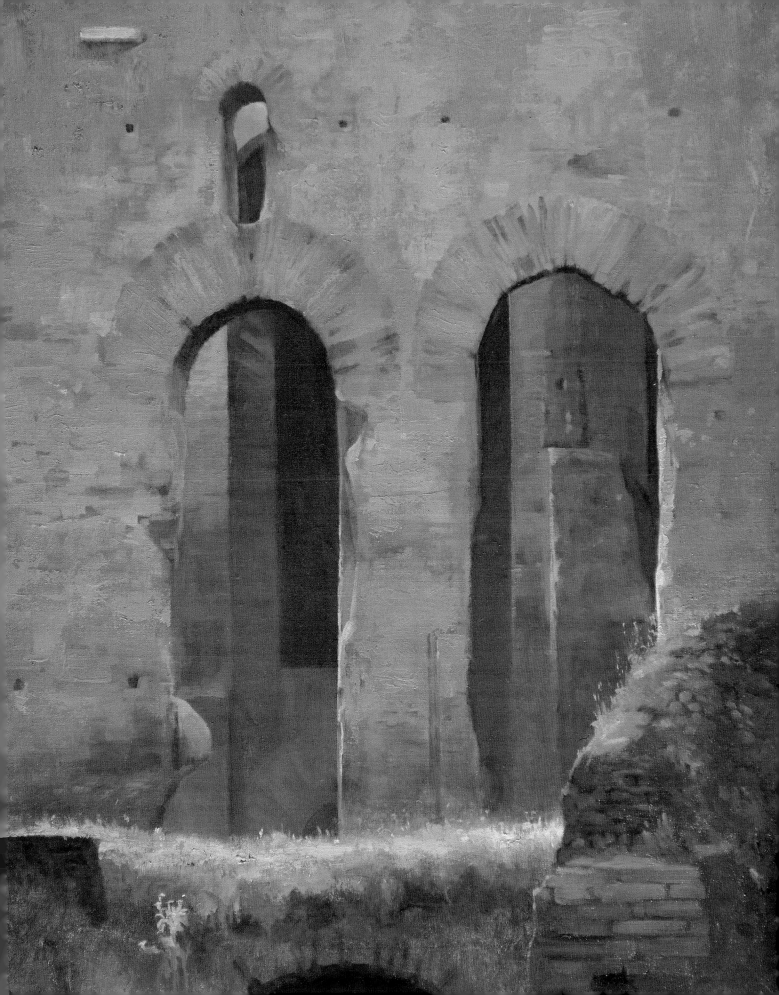

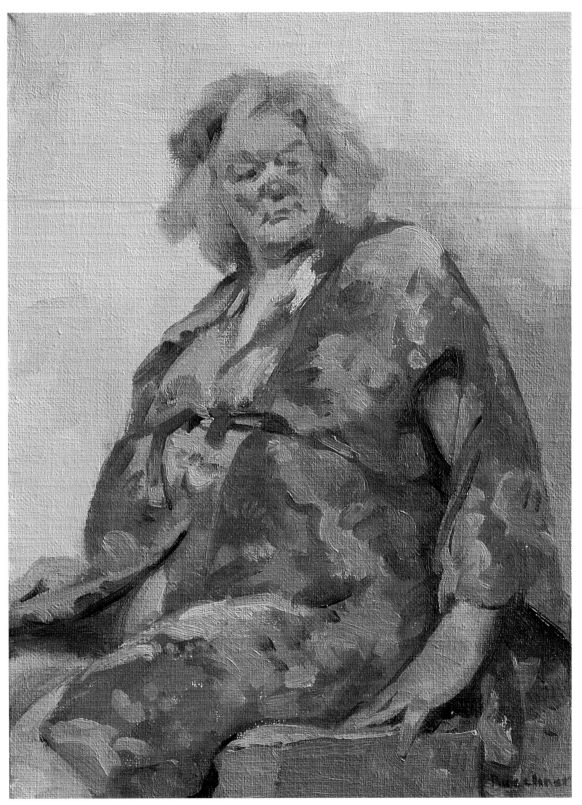

85

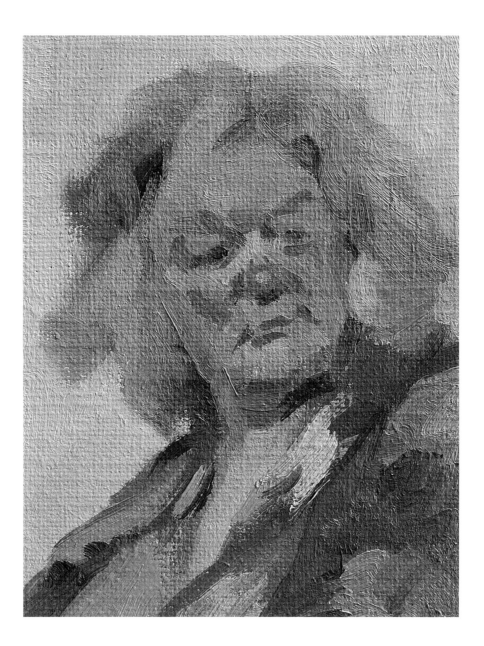

It should, by now, be evident, that I paint in several different ways (as do many painters), although my typical work is characterized by layering, the influence of my first great teacher. At the opposite end, or maybe at the beginning of all these options, is "alla prima," or all-at-once, painting. This means starting with a more-or-less white canvas, squeezing out a lot of paint, and going for the final result right off the bat, with no thought of underpainting, glazing, or scumbling **(85)**. Alla prima is exciting and has been by far the most popular way

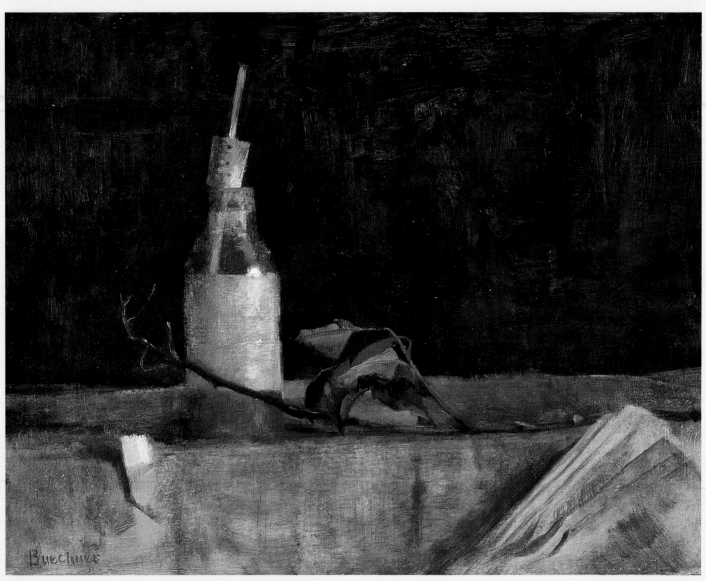

86

of painting for the last century and a half. Marvels have been accomplished, but in its energy and intensity, alla prima has literally obscured an important aspect of oil paint, its transparency **(86)**.

In the final painting, elements of each stage often remain visible, and in them one may be able to trace the history of the ultimate image. Here is a summary of the steps I take in composing and painting a picture. (The subject in **(87)** is Wotan, the one-eyed Norse god, inspired by a neighbor who had a fiberglass Viking helmet.)

 1. Thumbnail: to determine the tonal idea

 2. Drawing: to locate the key contrasts

 3. Imprimatura: to cover the surface and suggest the directions of the big forms

 4. Underpainting: to develop the dark-light design and model the forms

 5. Color: to finish with thin, transparent glazes and to overpaint thick lights, as if each stroke were my last

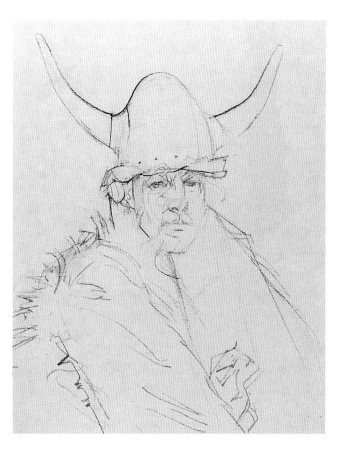

87

87

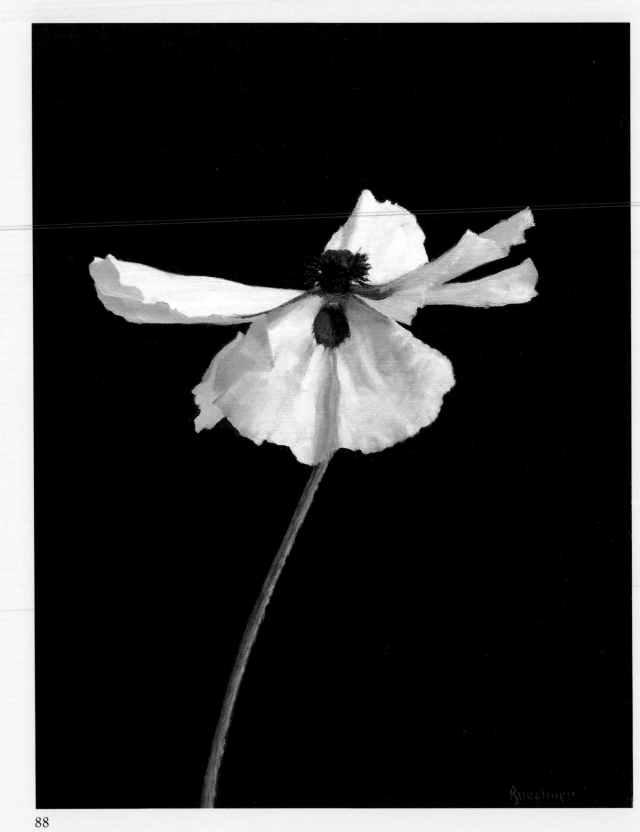

88

FINISHING

When I think a picture is finished, I put it in another place, away from the subject on which it was based. The paint is still wet, palette and brushes are still handy. It is in a different light and on its own. I am no longer busy with matching some reality. The question now is how to make it better, stronger, more to the point, maybe even striking. After all, it is destined to go out into the world all by itself.

What have I made? Is it just another sample of my craft? Does it have anything to do with the idea I started with? Pictures do have a life of their own, and a death, too. The more I look at something, the more I see, and discover. Changing course to some degree is inevitable, but if the whole picture isn't going in the same direction, to the same purpose, it is likely to fall apart, and my tolerance for flotsam is shrinking fast. What to do?

First, I decide what the picture is really about and then what I can get rid of, what is not contributing to the central idea, what is distracting. Usually, these problems are caused by small contrasts that divert attention, such as shifts in color or value, or intricate details painstakingly observed and proudly rendered. I painted them because I saw them, but that's not reason enough. You can spot a deer by a movement in the woods; you don't have to see the fuzz on its antlers to know it's there. Extraneous matter in a painting can really weaken the impact. I either paint it out or reduce the contrast.

Second, I review the way space has been made to see if I can heighten the illusion. Have I used the warm colors to pull things forward, the cools to push them back? Have I used stronger contrasts in the foreground, weaker ones in the background? Have I used less detail as forms recede? Have I used perspective effectively? Sequence of brushstrokes?

Third, I check how attention is focused. The eye is just like a self-focusing camera lens in that it must have an edge, a contrast, on which to focus. Where are the strongest contrasts in dark and light, warm and cool, color, edge sharpness, and paint texture? Do the contrasts make sense in terms of the spatial relationships? A ship on the distant

horizon with too-red sails will certainly attract attention—and ruin any sense of aerial perspective. Contrasts have to be appropriate to the space they are in, but they must also work in an abstract sense; they are the only means by which we can attract attention and deliver content.

Fourth, and finally, I look for a situation or two where a couple of final, exquisitely deft strokes will convince everybody that I know what I'm doing.

Varnishing and Framing

There is another grand moment in finishing, and that's when the varnish goes on. The dull spots disappear and colors become deeper, especially the darks. Light reflects off the shiny paint ridges, and the surface is unified into a single plane. I paint with alkyds, which dry overnight, so the next day I can cover my picture with a layer of Liquin, rub off the excess with a paper towel, and see the final value of the colors I have been using. Slow-drying oils take much more time, weeks sometimes, and final varnishing has to be delayed a whole year (only a month with alkyd). The purpose of this final layer is not just cosmetic. Varnishing also protects the paint surface and can be removed and replaced years hence if the picture is professionally cleaned. The choice of the right varnish—high gloss, matte, or in between—depends to some degree on the tonality of the picture and where it will hang. A dark picture covered with shiny varnish hung opposite a bright window will be impossible to see.

Framing is putting the bride in her wedding dress, and it is just as susceptible to individual taste. I am happiest when galleries frame my pictures for their clients because they all differ. New York likes float frames, Newport likes antique gold, Denver likes something brighter. Somebody has to decide whether the frame is intended to enhance the picture or to provide an appropriate transition to the wall in a specific location. An ornate period frame can look just as silly in a minimalist setting as a welded steel frame looks on linenfold paneling. I prefer uncarved, traditional moldings (Italian, Spanish, or American pre-1850) with gold leaf over a red ground, toned down and beaten up (distressed). These frames are expensive and fragile. The frame-maker assembles the specified molding and then covers the wood with gesso, so that there are no seams in the corners. Each has a large range of

finishes, including different-colored clays to put under the gold, so I can usually get the color, tone, and texture I want. Most good framers, even in small cities, can order custom frames, and many keep a number of sample corners on hand to show what is available. Because I paint so many pictures and do a lot of packing and shipping, I tend to buy rugged, inexpensive frames cut from commercial moldings **(89A)**. I wish I didn't, because my work always looks better in an expensive frame **(89B)**.

89

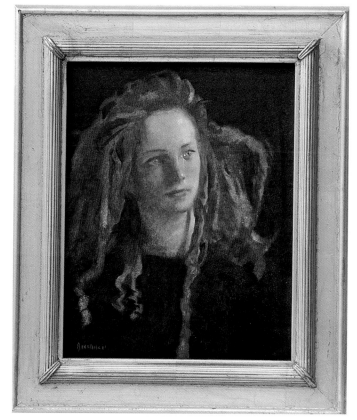

A Cheap

B Expensive

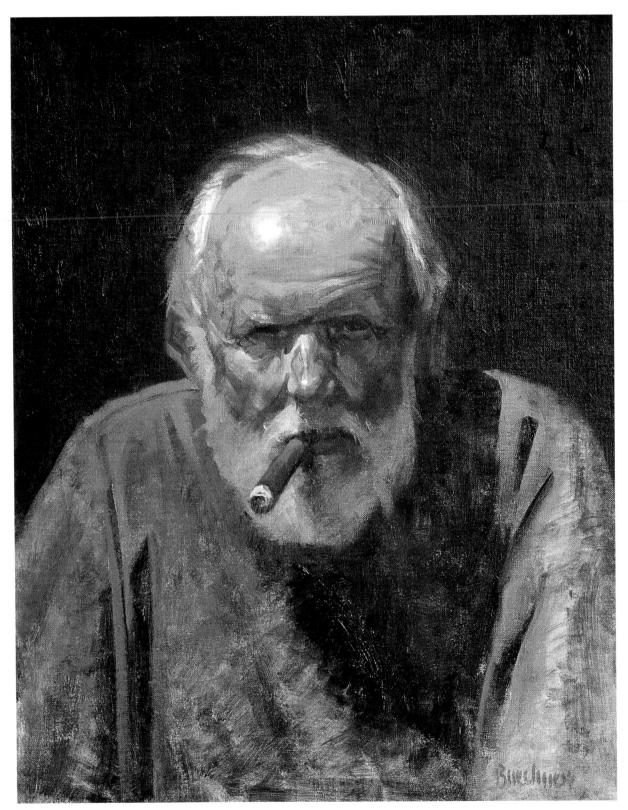

90

The Ten T's

Painting is a moving target. The better I get, the more I can appreciate it—and the greater the distance grows between me and the giants I so admire. Good painters are supposed to have the Ten T's:

Talent

Training

Tools

Technique

Temperament

Time

Tenacity

Tendentiousness

Temerity

Taste

Great painters have one thing more—genius. It can't be learned, but it can be seen, in how *they* paint.

When I finally saw *Washington Crossing the Delaware* up close, I saw more than a painting. I saw the paint itself and the brushstrokes that delivered the paint. Seeing that picture made me want to paint. Every picture I admire draws me in close to see how it was done, to enjoy the performance, to learn something. Good pictures make me want to paint. This is my primary motivation and it never diminishes, because the more I learn the more I see and the higher my standard goes. The Rembrandt of my childhood is a pygmy compared to the Rembrandt of my old age. There is real elation for me in observing the masters at work, and numbing despair in continuously rediscovering my own limitations. But once in a while I will paint better than I thought I could, and that makes me eager to press on.

APPENDIX

Chronology

1926 Born in New York City

1944 Graduates from the Lawrenceville School; enters Princeton University in U.S. Navy V-5 program

1945 Works as architectural draftsman in Puerto Rico

1946 Works as elevator operator at the Plaza Hotel, New York, and attends Art Students League

1947 Studies at the École des Beaux-Arts, Paris, and with M. M. van Dantzig, Amsterdam

1948 Works in display department, the Metropolitan Museum of Art

1949 Marries Mary C. Hawkins

1950 Appointed first director of the Corning Museum of Glass

1951 Daughter, Bohn, is born

1954 Son Thomas is born

1957 Son Matthew is born

1960 Appointed director of the Brooklyn Museum

1961 Begins painting with David Levine and Aaron Shikler (through 1985)

1965 Joins Portraits, Inc.

1970 Writes *Norman Rockwell: Artist and Illustrator* (Abrams)

1971 Rejoins Corning Glass Works

1973 Appointed president of Steuben Glass (through 1984)

1975 Begins teaching through 171 Cedar Arts Center (through 1999)

1982 First solo exhibition in New York City, at A. M. Adler Fine Arts

1985 First solo museum exhibition, Arnot Art Museum, Elmira, New York

1987 Begins painting full time

1988 Teaches workshops in Scottsdale, Arizona; Loveland, Colorado; and Frauenau, Germany (through 1999)

1999 Still painting in Corning

Artist Teachers

(from whom I have taken classes* or workshops** or with whom I have painted)

Clyde Aspevig**	Wilson Hurley	John C. Pellew**
Will Barnet*	Robert Johnson*	Martin Alan Poole
George Cherapov**	Greg Kreutz**	Richard Schmid**
Peter Cox**	T. Allen Lawson**	Aaron Shikler*
Erwin Eisch	David Leffel**	Burton Silverman**
Tom Gardner	David Levine*	W. C. Simmons
Daniel Greene**	Martin Lewis*	Harry Sternberg*
David Higgins	Kenneth Hays Miller*	Zoltan Szabo**

Bibliography

Artists' Monographs

I have well over one hundred picture books reproducing the work of individual artists. Here are some of those that I use most.

Baetjer, Katharine, and J. G. Links. *Canaletto.* New York: The Metropolitan Museum of Art, 1989

Baticle, Jeannine, et al. *Zurbarán.* New York: The Metropolitan Museum of Art, 1987

Bonafoux, Pascal. *Portraits of the Artist: The Self-Portrait in Painting.* New York: Skira/Rizzoli, 1985

Brown, Jonathan. *Velázquez: Painter and Courtier.* New Haven: Yale University Press, 1986

Cikovsky, Nicolai, Jr., and Michael Quick. *George Inness.* Los Angeles: Los Angeles County Museum of Art, 1985

Conisbee, Philip. *Georges de La Tour and His World.* Washington: National Gallery of Art, 1996

De Veer, Elizabeth, and Richard J. Boyle. *Sunlight and Shadow: The Life and Art of Willard L. Metcalf.* New York: Abbeville, 1987

Elderfield, John and Robert Gordon. *The Language of the Body: Drawings By Pierre-Paul Prud'hon.* New York: Harry N. Abrams, 1996

Hendricks, Gordon. *The Life and Work of Thomas Eakins.* New York: Grossman, 1974

Hibbard, Howard. *Caravaggio.* New York: Harper & Row, 1982

Holbein and the Court of Henry VIII. London: The Queen's Gallery, Buckingham Palace, 1978–79

Kilmurray, Elaine, and Richard Ormond. *John Singer Sargent.* London: Tate Gallery, 1998; Princeton, N.J.: Princeton University Press, 1998

Lampert, Catherine. *Lucian Freud: Recent Work.* London: Whitechapel Art Gallery, 1993; New York: Rizzoli, 1993

Levine, David. *The Arts of David Levine.* New York: Alfred A. Knopf, 1978

Pickvance, Ronald. *Van Gogh in Saint-Remy and Auvers.* New York: The Metropolitan Museum of Art, 1986

———. *Van Gogh in Arles.* New York: The Metropolitan Museum of Art, 1984

Quick, Michael, et al. *The Paintings of George Bellows.* New York: Harry N. Abrams, 1992

Rebora, Carrie, et al. *John Singleton Copley in America,* New York: The Metropolitan Museum of Art, 1995

Schau, Michael. *J.C. Leyendecker.* New York. Watson-Guptill, 1974

Sutton, Denys. *Edgar Degas Life and Work.* New York: Rizzoli, 1986

Tinterow, Gary, Michael Pantazzi, and Vincent Pomarède. *Corot.* New York: The Metropolitan Museum of Art, 1996

Valcanover, Francesco, et al. *Titian.* Washington: National Gallery of Art, 1990

Wetering, Ernst Van de. *Rembrandt: The Painter at Work.* Amsterdam: Amsterdam University Press, 1997

Wheelock, Arthur K., Jr., et al. *Anthony van Dyck.* New York: Harry N. Abrams, 1990

———. *Vermeer and the Art of Painting.* New Haven: Yale University Press, 1995

Wildenstein, Georges. *Chardin.* Greenwich: New York Graphic Society, 1963

Yurova, Tamara. *Levitan.* Leningrad: Aurora, 1980

General Books

The following are some of the books I have found most helpful, going all the way back to my first art book, Thomas Craven's *A Treasury of Art Masterpieces,* which I got for Christmas in 1939.

Bridgeman, George B. *Constructive Anatomy*. Pelham, N.Y.: Dover, 1976

———. *The Seven Laws of Folds*. Pelham, N.Y.: Bridgeman Publishers, Inc, 1942

Bustanoby, J.H. *Principles of Color and Color Mixing*. New York: McGraw-Hill, 1947

Campbell, Lorne. *Renaissance Portraits: European Portrait Painting in the 14th, 15th, and 16th Centuries*. New Haven: Yale University Press, 1990

Carlson, John F. *Carlson's Guide to Landscape Painting*. New York: Dover, 1958

Cateura, Linda. *Oil Painting Secrets From a Master*. New York: Watson-Guptill, 1984

Cooke, Hereward Lester. *Painting Lessons from the Great Masters*. New York: Watson-Guptill, 1968

Craven, Thomas. *A Treasury of Art Masterpieces, from the Renaissance to the Present Day*. New York: Simon and Schuster, 1939

Doerner, Max. *The Materials of the Artist and Their Use in Painting, with Notes on the Techniques of Old Masters*. New York: Harcourt, Brace, 1934; revised edition, 1962

Freeze, Ernest. *Perspective Projection: A Simple and Exact Method of Making Perspective Drawings*. New York: Pencil Points, 1938

Herridgeham, Christina. *The Book of Art of Cennino Cennini*. London: George Allen, Ruskin House, 1899

Loomis, Andrew. *3-Dimensional Drawings*. New York: The Viking Press, 1958

———. *Drawing The Head And Hands*. New York: The Viking Press, 1956

Nicolaides, Kimon. *The Natural Way to Draw: A Working Plan for Art Study*. Boston: Houghton Mifflin, 1941, 1975

Norto, Miriam. *Freehand Perspective*. New York: Sterling, 1957

Schmid, Richard. *Alla Prima: Everything I Know About Painting*. Boulder: Stove Prairie Press, 1998

Schneider, Norbert. *Art of the Portrait: Masterpieces of European Portrait-Painting*. Cologne: Benedikt Taschen, 1994

Watson, Ernest W. *Creative Perspective for Artists And Illustrators*. New York: Dover, 1992

———. *Perspective For Sketchers*. New York: Reinhold, 1964

Glossary

Agate burnisher A tool, usually a rounded piece of agate set in a wooden handle, used for smoothing and polishing certain surfaces, such as plaster, gesso, or gold leaf

Alla Prima A technique of oil painting, also called direct painting, in which a work is completed in a single layer (with no underpainting), and usually in one sitting, while the paint is still wet and maneuverable

Alkyd A type of quick-drying paint (sold by Winsor & Newton under the name Griffin) that utilizes a synthetic resin rather than linseed oil and can be mixed with oil colors

Chiaroscuro A technique introduced in the Renaissance that produces the illusion of depth and three-dimensional form through the contrast of light and dark areas, often with a single, bright light source

Composing Dividing up the flat space on canvas, or arranging the objects to be painted in a still life, or posing a model for a portrait

Conté A well-known type of hard, square crayon resembling chalk or pastel—usually brown, black, or white—long popular for drawing because of its subtle tonal range under various pressures

Gesso A white, plasterlike coating material traditionally made of pigment, chalk, water, and glue and applied in layers on wooden panels as a ground before painting in tempera (the gesso must be sized, or isolated with a thin layer of glue or gelatin, before oil paints can be used). With the advent of artificial resins, today's commercial gessoes are much more flexible and can be used on canvas and on rigid supports such as Masonite.

Glaze In oil painting, a thin, transparent layer of paint applied over a dry, lighter-colored underpainting to produce a luminous effect impossible to achieve with opaque colors

Hue A color, identified by a common name such as red or blue. The hues of the rainbow include the primaries—yellow, red, and blue—and the secondaries—orange, purple, and green; gray and brown are neutral hues.

Impasto Thickly applied, usually opaque, paint, in which the marks left by the brush or palette knife remain clearly visible

Imprimatura In oil painting, a first layer of color covering the entire surface to provide a middle tone or a unifying color for the work that is to be painted over it

Liquin A synthetic resin medium made by Winsor & Newton often used to replace oil, because it is faster drying, excellent for glazing, and non-yellowing

Local color The true color, or hue, of an object, as opposed to the way it may appear in certain lighting conditions, at a distance, or in contrast with other colors

Mineral spirits A paint thinner and brush cleaner for use with oil and alkyd paints

Palette The surface on which paint is mixed and a particular painter's choice of colors. Examples: My palette is made of wood. My palette consists primarily of burnt sienna and raw umber.

Palette knife A tool used primarily for mixing paint or scraping it off a palette. Knives with flexible blades in a variety of shapes can also be used for applying or smoothing paint on the picture itself.

Plein air A French term meaning "open air" that refers to the act of painting outdoors rather than in the studio

Poster colors Inexpensive opaque colors with a water-soluble glue base that are used to create flat areas of color

Scumble A layer of opaque paint brushed or dragged lightly over a surface so that the colors underneath are not entirely obscured. The term can also refer to a translucent, lighter color painted over a darker one to cool and dull the effect. In this sense, the scumble has the reverse effect of a glaze, which warms and brightens.

Texture The smoothness or roughness of paint itself or of the surface on which paint is applied

Tint A color, or hue, to which white has been added. Example: a series of progressively lighter tints of the same color can be achieved by adding increasing amounts of white.

Tone A term used to refer to the quality of a color, particularly its temperature and relative lightness or darkness. Example: Yellow is warmer and lighter in tone than blue.

Underpainting Forms and colors laid down in anticipation of the impact they will have on colors to be painted over or adjacent to them; frequently, the first layer in which both form and the effects of light and dark are developed in tones and tints of one color

Value This term is used to refer to the relative lightness or darkness of colors on a scale of grays running from black to white

Varnish A resin oil, or its synthetic equivalent, which is painted or sprayed on after a painting is thoroughly dry (a year for oils, a month for alkyds) to protect the surface and to unify the reflective differences of the colors; varnishes range from dull to shiny.

LIST OF ILLUSTRATIONS

26. Composition Diagrams

27. *La Rocca,* 1993. Oil/alkyd on canvas, 11 x 14". TSB

28. *Shon (Profile),* 1997. Oil/alkyd on canvas, 14 x 11". TSB

29. *Villa Ughetta,* 1999. Oil/alkyd on canvas, 16 x 20". William C. Ughetta

30. *Onion,* 1997. Oil/alkyd on board, 16 x 20". Emily and Zach Smith

31. *Fred Kirby,* 1997. Oil/alkyd on canvas, 42 x 32". Lawrenceville School

32. *Yellow House,* 1984. Oil on canvas, 24 x 36". George L. Howell

33. *Lady in Black,* 1978. Charcoal and conté on paper, 26 x 18". Mr. and Mrs. Robert E. Duke

34. Light and Shade Diagrams

35. *The Fisherman,* 1995. Oil/alkyd on canvas, 24 x 60". Barbara Dau Southwell

36. Aerial Perspective Diagrams

37. *Chemung Valley,* 1989. Oil/alkyd on canvas, 30 x 40". Elmira City Club

38. *Black Dress,* 1978. Oil on canvas, 12 x 9". TSB

39. *Flora,* 1995. Oil on canvas, 40 x 30". Private collection

40. Illusion of Space Diagrams

41. *Central Park Boat Pond,* 1986. Oil on canvas, 24 x 36". James Q. Riordan

42. *Little Pumpkin,* 1993. Oil/alkyd on board, 11 x 14". Mr. and Mrs. John S. McClelland, Jr.

43–48. *Three Pears,* 1998. Oil/alkyd on board, 16 x 20". Mr. and Mrs. Bran Ferren

49. *Gladiola,* 1990. Oil/alkyd on board, 14 x 11". Les and Jill Lewis

50. *Three Last Sunflowers,* 1995. Oil/alkyd on canvas, 30 x 30". Private collection

51–54. *Daffodils,* 1999. Oil/alkyd on board, 20 x 15". TSB

55. *Survivor,* 1983. Oil on canvas, 24 x 38". Paul R. Johnston

56. *Mintz Barn,* 1982. Oil on canvas, 7 x 10". Martin E. Segal

57. *Mintz Barn,* 1990. Oil/alkyd on canvas, 20 x 24". Private collection

58. *Mintz Barn,* 1989. Oil/alkyd on panel, 10 x 12". Private collection

59. *Mintz Barn,* 1995. Oil/alkyd on board, 11 x 14". Mr. and Mrs. J. A. Mills

60. *Pink Barn, Loveland,* 1997. Oil/alkyd on panel, 7 x 14". Mr. and Mrs. Bowen King

61. *Baroque of Collapse,* 1991. Oil/alkyd on canvas, 11 x 14". TSB

62. *Baroque of Collapse,* 1991. Oil/alkyd on canvas, 30 x 40". TSB

63. *Forum from the Farnese,* 1992. Oil/alkyd on board, 14 x 11". TSB

64. *Rome,* 1992. Oil/alkyd on canvas, 50 x 30". Private collection

65. *Bill,* 1980. Oil on canvas, 50 x 30". National Museum of American Art

66–69. Diagram Sketches

70. *Jarvis Langdon,* 1985. Oil on canvas, 50 x 30". The Center for Mark Twain Studies

71. *Rev. Charles Clark,* 1992. Oil/alkyd on canvas, 50 x 30". St. Paul's School

72. *Philip Jordan,* 1996. Oil/alkyd on canvas, 36 x 24". Lawrenceville School

73. *Man with Book,* 1997. Oil/alkyd on canvas, 50 x 30". Mr. and Mrs. John D. Macomber

74–76. *Thorne Brothers,* 1994. Oil/alkyd on canvas, 30 x 40". Mr. and Mrs. Nathan C. Thorne

77. *Boy Reading,* 1991. Oil/alkyd on anvas, 26 x 22". Mr. and Mrs. Amory Houghton, Jr.

78. *Joe,* 1990. Oil on canvas, 30 x 24". TSB

79. *Tamar,* 1997. Oil/alkyd on canvas, 24 x 20". Mary C. Hickey

80. *Trout,* 1993. Oil/alkyd on panel, 16 x 12". Private collection

81. Brush Diagrams

82. *Corfu Olive,* 1981. Oil on panel, 12 1/4 x 16". TSB

83. *Barn Frame,* 1983. Oil on panel, 12 x 16". Howard H. Kimball

84. *In the House of Septimus Severus,* 1993. Oil/alkyd on canvas, 30 x 24". Bohn and Scott Whitaker

85. *Model In Kimono,* 1985. Oil on canvas, 12 x 9". TSB

86. *Glue Bottle,* 1993. Oil/alkyd on board, 11 x 14". TSB

87. *Wotan (In 5 Stages),* 1999. Oil/alkyd on canvas, 20 x 16". TSB

88. *One White Poppy.* 1995. Oil/alkyd on canvas, 18 x 14". Mr. and Mrs. Robert E. Duke

89. Production and Custom Frames

90. *A Peek in the Mirror,* 1998. 20 x 16". Janet and Gary Freese

91. *"Dort Liegt Der Wurm,"* 1987. Stained glass, 10 x 7". TSB

Pages 124–25. *Boy in Straw Hat.* 1999. 16 x 20". Mr. and Mrs. José Diaz

Endpapers. *Welles' Farm* (detail), 1983. Oil on canvas, 18 x 24". Chemung Canal Trust Company

"DORT LIEGT DER WURM"

91

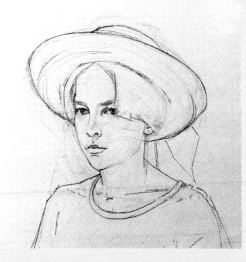
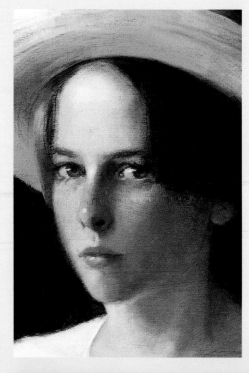
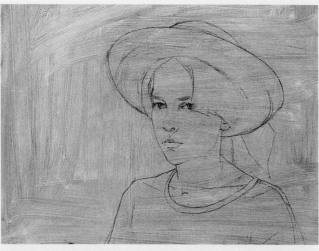
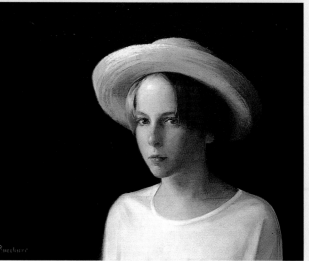
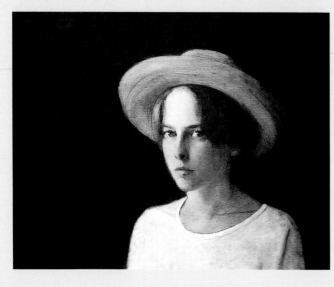

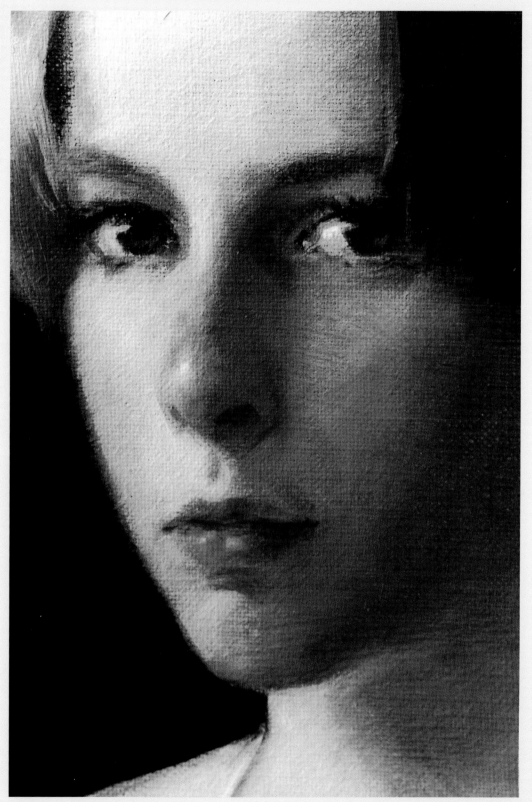

92

INDEX

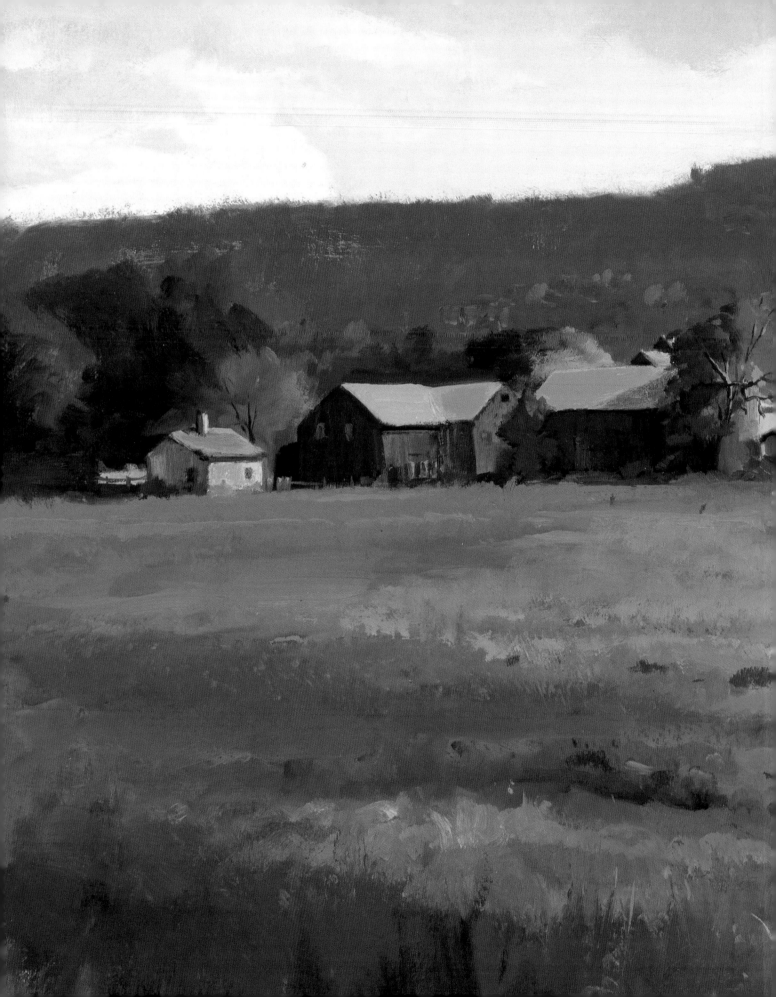